MW00415104

IMAGES
of America

BRISTOL
HISTORIC HOMES

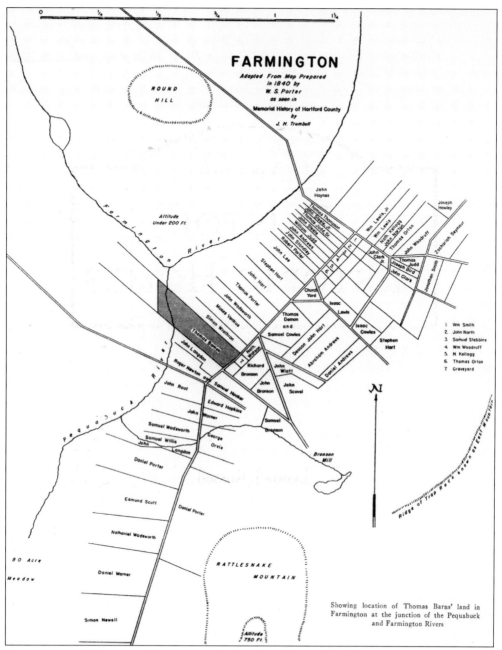

FARMINGTON. This map of Farmington shows where Thomas Barns, father of Ebenezer Barns, and some of the 84 proprietors lived. Most of them settled on what is now Main Street, which was the first road through the Colonial village.

On the cover: This photograph of the Chauncey Jerome home was taken around 1880 after Joel T. Case remodeled it. (Courtesy of the American Clock and Watch Museum.)

IMAGES
of America

BRISTOL
HISTORIC HOMES

Lynda J. Russell

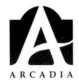

ARCADIA

Published by Arcadia Publishing
Charleston SC, Chicago IL, Portsmouth NH, San Francisco CA

Printed in Great Britain

Library of Congress Catalog Card Number: 2005937947

For all general information contact Arcadia Publishing at:
Telephone 843-853-2070
Fax 843-853-0044
E-mail sales@arcadiapublishing.com
For customer service and orders:
Toll-Free 1-888-313-2665

Visit us on the internet at http://www.arcadiapublishing.com

BRISTOL. This is a map of Bristol in 1776, prepared by Josiah T. Peck, showing where the early settlers lived.

CONTENTS

ACKNOWLEDGMENTS

Once the public, individuals, and various groups heard about publishing a book on historic homes, I received many pictures from many private collections, along with stories about the pictures.

I would like to thank the following: City of Bristol, Bristol Public Library, Bristol Historical Society, American Clock and Watch Museum, and the Greater Bristol Chamber of Commerce.

Special thanks go to Gail Leach (my mentor), Dawn Ledger, Jerry Herecko, Don Muller, Chris Bailey, Milton and Verna Carlson, John Gorman, Peter Dziekan, Gary Potter, and my family, who helped me from the start.

All proceeds from the sale of this book will go to the Quota International of Bristol's Scholarship Fund.

INTRODUCTION

In 1636, Rev. Thomas Hooker and about 100 people settled along the Connecticut River in an area now known as Hartford. As the population grew, settlers went west near the Farmington River, where the Tunxis Indians lived.

In 1640, the Farmington Parish, which included Bristol, Burlington, Avon, Plainville, Southington, Forestville, New Britain, and Berlin, was established. It became incorporated in 1645. The West Woods section of Farmington stayed unsettled until 1728, when Ebenezer Barns became the first permanent settler. His father, Thomas Barns, was one of the Farmington proprietors who had been granted land. Other early settlers followed, and in 1744, New Cambridge became a parish. The first church and school were erected on Federal Hill, and the common green was used for militia training. New Cambridge became the Town of Bristol in 1785.

After Middle Road Turnpike (Route 6 today) opened in 1803, commercial activity began with North Village, where stores opened and prospered. The South Village, along the Pequabuck River, also grew in the 1820s near the location of the Chauncey Jerome Clock Shop. In 1850, the Hartford, Providence and Fishkill Railroad passed through the North and South Villages of Bristol. A depot was then placed between these two villages, establishing the downtown area of Bristol.

As industry grew from clock making to other manufacturing, several families became very wealthy and built elaborate homes on Federal Hill. They included the Ingraham, Sessions, Treadway, Peck, Barns, Seymour, Page, and Rockwell families, who are all noted in this book.

As new families arrived, some worked in the factories, while others started their own businesses. Because of this, homes and apartments were built all over town.

I dedicate this book to the people of Bristol, past and present, who have made Bristol the great city it is today.

FEDERAL HILL GREEN. This is an early view of Federal Hill Green.

One

EARLY SETTLEMENT
1728–1799

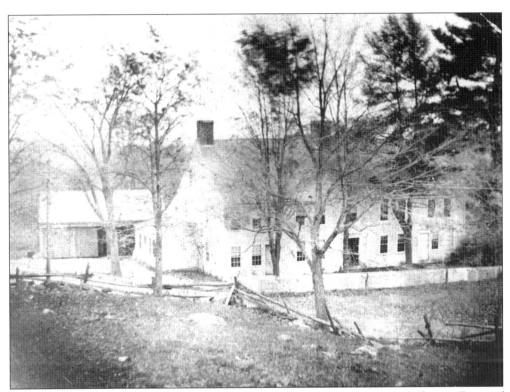

KING'S HIGHWAY (NOW KING STREET). Ebenezer Barns, youngest son of Thomas Barns of Farmington, became the first permanent settler of West Woods in 1728. He lived in this home, which was built on the land that was originally given to his father in 1663. Eventually, the home became a tavern and was later owned by the Pierce family, who stayed there through five generations. At its demolition in 1939, it was 211 years old.

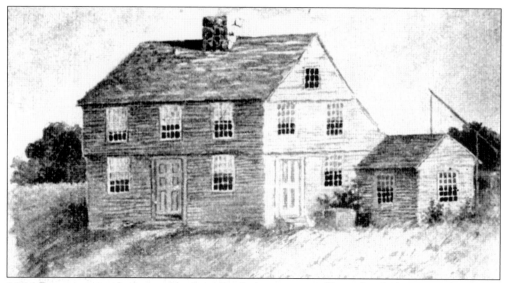

1276 Burlington Avenue. Abraham Bartholomew, son of Isaac Bartholomew and Rebecca Bartholomew (née Frisbie), and his wife, Hannah Bartholomew (née Page), owned this house, known as Bartemy Tavern. Built around 1785, it was located between two parishes, West Britain (now Burlington) and New Cambridge. The first town meetings were held across the street, under a tree known as the Peaceable Oak Tree.

Chippens Hill. Steven and Ruth Graves lived in this area, known as the Ledges, near Tory's Den. Large bands of patriots hid here. The home was later owned by Prof. John C. Riggs around 1778.

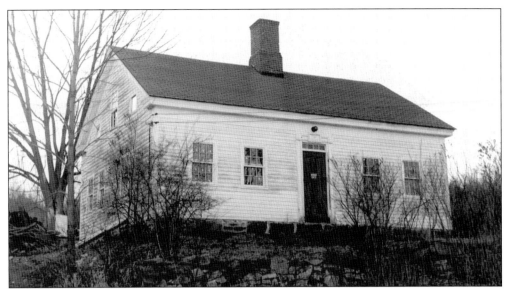

14 DANIEL ROAD. Benjamin Buck and his wife, Mercy Buck (née Parsons), originally from Southington, built this home in 1729. They lived here until 1736. Others who lived here were Ebenezer Hambil, Eliezer Peck, Obadiah Andres, Asa Upson, and the Parsons family. This is the oldest home in Bristol.

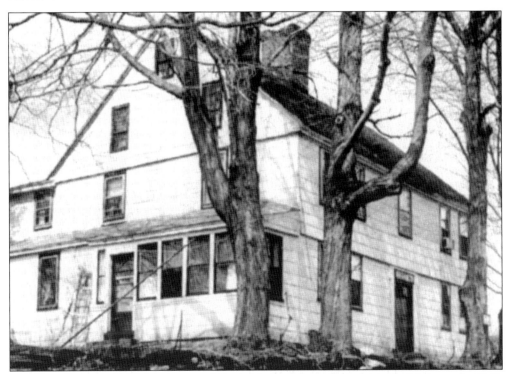

105 HILL STREET. Caleb Mathews and Ruth Mathews (née Connor) built this home in 1745. They were two of the first settlers in this area. Mathews helped form the first militia company. His daughter Chloe Mathews married Constant Loyal Tuttle, and later the home became known as the Constant Loyal Tuttle House. The house still stands today.

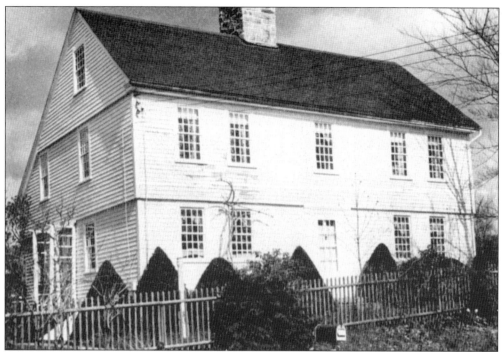

367 JEROME AVENUE. William Jerome, son of Timothy Jerome and Abigail Jerome (née Rich), came to New Cambridge in 1741 with his two brothers, Timothy and Zerubbabel. William and his wife, Elizabeth Jerome (née Hart), bought the land adjacent to this home in 1741, and in 1742, they purchased this home from Caleb Palmer, the original builder. The Jeromes were one of the first families to own slaves in the area, and once freed, they continued to live on the property.

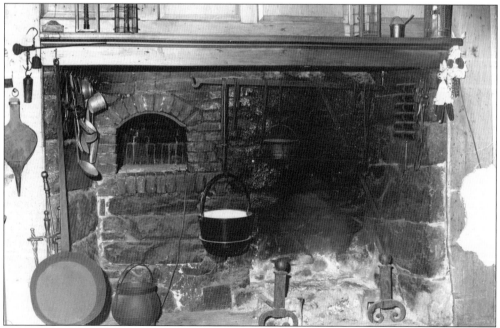

JEROME KITCHEN. This photograph of the Jerome kitchen shows a typical Colonial oven.

529 JEROME AVENUE. This home was originally built in 1760 by William Jerome II. It was purchased in 1807 by Asa Bartholomew, the son of Jacob Bartholomew and Sarah Bartholomew (née Fridley), who owned the Bartemy Tavern. Asa (below) married Charity Bartholomew (née Shelton), and they had eight children: Emily, George Wells, Harry Shelton, Paulina, Jennette, Asa, Nancy Marie, and Jane Charity.

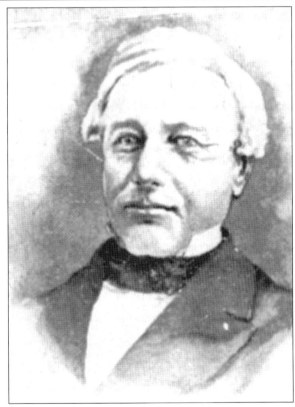

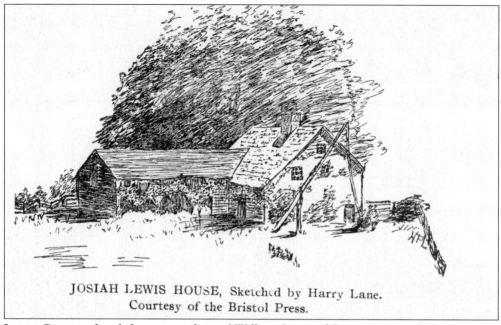

JOSIAH LEWIS HOUSE, Sketched by Harry Lane.
Courtesy of the Bristol Press.

LEWIS CORNER. Josiah Lewis, grandson of William Lewis of Farmington, and Phoebe Lewis (née Gridley) came to New Cambridge in 1745. They had nine sons and three daughters. As each son married, he was given a house and a barn that Josiah had built. He also gave each son a cow, a hive of bees, and a Waterbury Sweet apple tree.

11–13 LEWIS STREET. Eli Lewis, third son of Josiah and Phoebe Lewis, was a farmer. He kept detailed records of life in the 18th century. He joined the army in 1776 and accompanied George Washington as he crossed the Delaware. This house, built by Josiah Lewis in 1764, still stands today.

14

67 MAPLE STREET. This was the home of Benjamin Ray, a clock maker who owned the Ives Eureka Shop on North Main Street. The house was built around 1790 and still stands today.

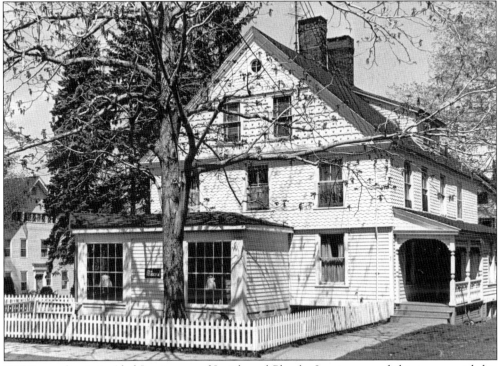

78 MAPLE STREET. Abel Lewis, son of Josiah and Phoebe Lewis, opened this tavern with his wife, Ruth, in 1794. The tavern became a popular place and held many dances.

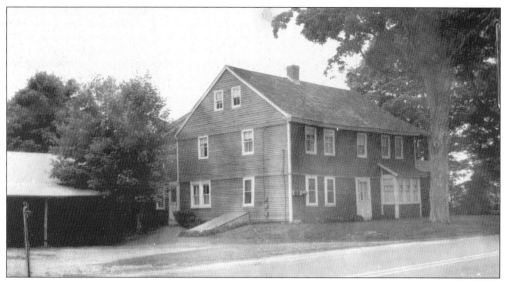

750 Matthews Street. This house, named the Isaac Shelton Home, was said to be a resting place for the Tories. Built around 1790, it became the home of Thomas Mitchell, son of William Mitchell, a weaver who originally came from Scotland.

54 Middle Street. This house was built in 1748 by Thomas Barns, son of the first settler, Ebenezer Barns, for his wife, Martha. Among the owners who lived here are the Gaylord, Cooke, Ives, Botsford, and Terry families. It became the home for the Bristol Historical Society in 1973.

860 STAFFORD AVENUE. This home, which still stands today, was built around 1760 by William G. Atkins, a prominent manufacturer who later became a foreman for New Departure Manufacturing Company.

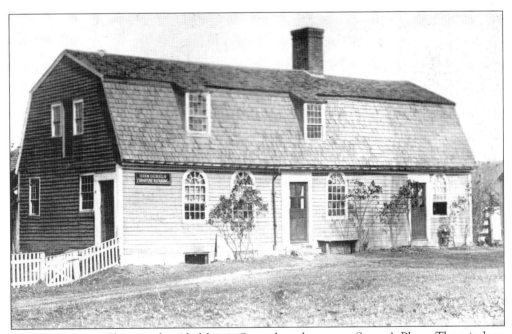

STEARN STREET. This was the Abel Lewis Store, later known as Stearn's Place. The windows came from the old Episcopal church. The building no longer stands.

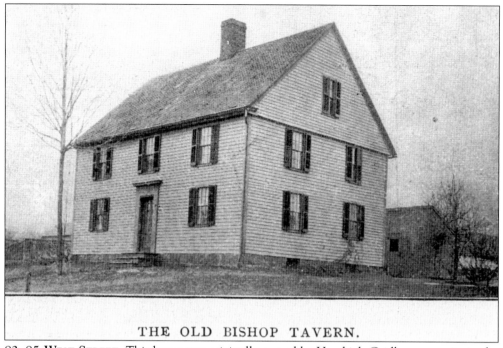

THE OLD BISHOP TAVERN.

83–85 West Street. This home was originally owned by Hezekiah Gridley, a captain in the Continental army. The home was used to store supplies for the army. Around 1780, Austin Bishop purchased this home. He established it as a tavern in 1783.

523 West Street. This house is the oldest home on this street. Built in 1783, it was owned by Daniel Roberts. Seth Barnes purchased this house, and his descendants owned the property for over a century until it was acquired by the Calvary Advent Christian Church as a parsonage.

35 Wolcott Street. This home, built in 1770, is one of the oldest homes in the area. It was owned by Chandler Norton, a family member of the prominent Norton family. Members of the Norton family were farmers, bankers, industrialists, and owners of the historic Lake Compounce. Later the home was owned by George A. Rowe, a mason by profession.

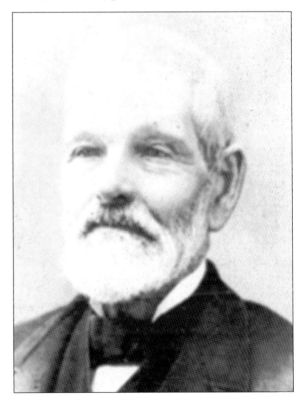

Gad Norton. Gad Norton, the son of Parrish D. Norton and Betsy Norton (née Rice), was born on October 24, 1815. He was a descendant of John Norton, one of the original 84 proprietors of Farmington. He was a farmer and inherited Lake Compounce, which he opened with Isaac Pierce in 1846. He died on May 4, 1898.

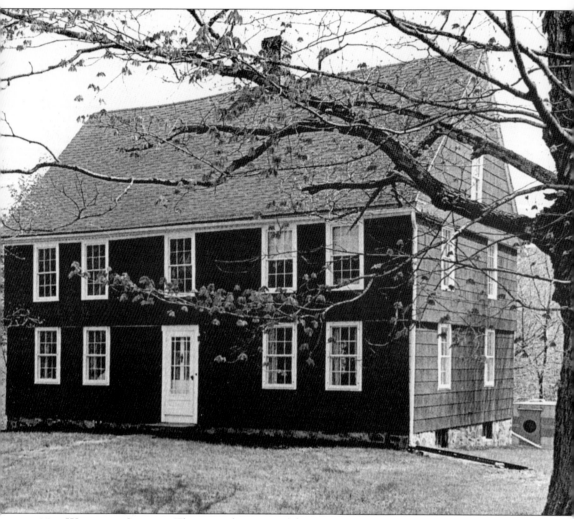

391 WOLCOTT STREET. This was the original home of Moses Lyman, who purchased the land in 1732 and built the house in 1736. Daniel Mix, a blacksmith, lived here for a short time until Elias Roberts and his wife, Susanna Roberts (née Ives), purchased the home, along with additional land, in 1746. Elias was a carpenter and, together with his son Gideon, started making wooden clocks. Gideon continued to make clocks and lived there with his wife, Falia Roberts (née Hopkins). He died in 1813, at the age of 64.

Two

CLOCK MANUFACTURING
1800–1870

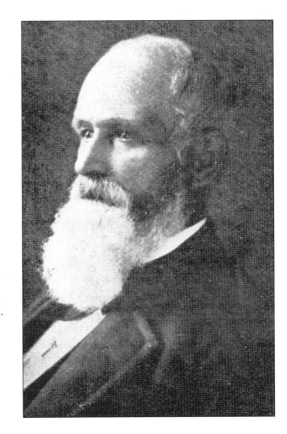

ELISHA N. WELCH. Born on February 7, 1809, in Chatham East Hampton, Elisha N. Welch came to Bristol with his father to cast clock weights. He later purchased the J. C. Brown Clock Factory, which became E. N. Welch Manufacturing. He was also the founder of the Bristol Brass and Clock Company. It is said that he was the first millionaire in Bristol.

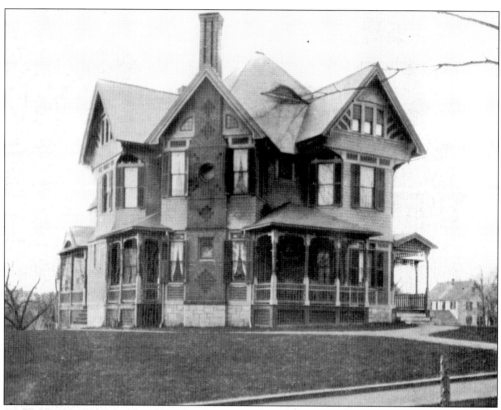

35 BELLEVUE AVENUE. In 1873, this house was built for George W. Mitchell, son of Julius R. and Drusilla W. Mitchell. He was the owner of J. R. Mitchell and Sons Clothing store, which was started by his grandfather Hon. George Mitchell and Thomas Barns Jr. He was married to Eva L. Dunbar, daughter of Edward L. Dunbar. The home is now owned by Funk Funeral Home.

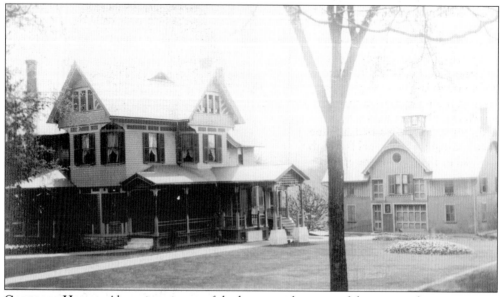

CARRIAGE HOUSE. Above is a picture of the house, with a view of the carriage house.

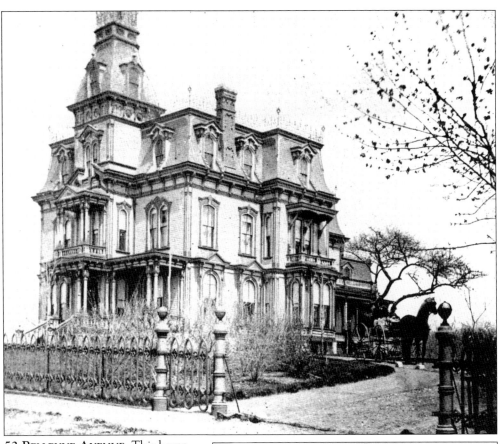

52 BELLEVUE AVENUE. This home was built in 1874 for Nathan Loomis Birge, son of John Birge and Betsy Birge (née Loomis). Nathan Birge was born in 1823 on his father's farm near Lewis Street. His father was a skilled carpenter who went into the clock business with Harvey and Erastus Case and Joseph Ives. Nathan (right) went to Europe to sell clocks for the company, and upon his return, he married Adeline Smith, daughter of Samuel B. Smith. He died in 1899, at the age of 76.

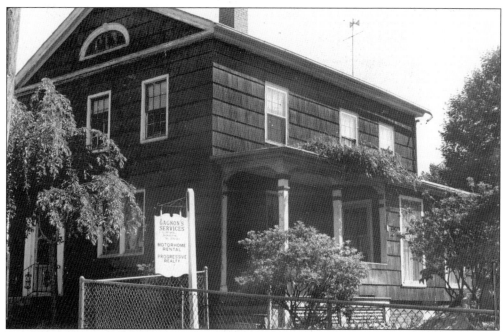

20–22 BURLINGTON AVENUE. Andrew Ingraham, brother of clock maker Elias Ingraham, built this home in 1837. Upon the death of his first wife, Andrew remarried and moved to a farm in another state. He moved back to Bristol, and in 1877, at the age of 70, he added on to the home.

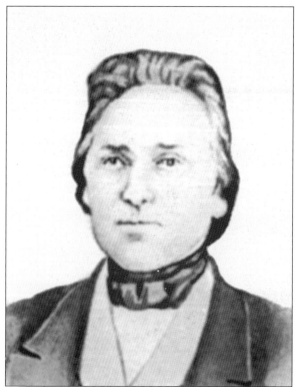

ELIAS INGRAHAM. Elias Ingraham came to Bristol in 1824, at the age of 19, to work for the Honorable George Mitchell, making clock cases. He was married to Julia Sparks and had one son named Edward I. In 1852, Elias and his brother, Andrew, started a clock manufacturing company with the financial backing of Elisha C. Brewster. The company Brewster-Ingrahams was formed. In 1852, Brewster withdrew from the company, and it became E. and A. Ingraham. Andrew continued the business with Elias's son, Edward I. In 1880, the company became E. Ingraham and Company. Elias died in 1885, and Edward I succeeded as president.

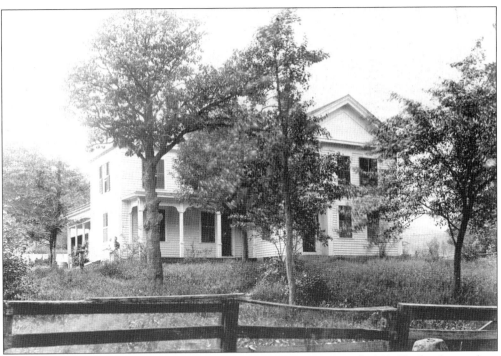

839 BURLINGTON AVENUE. This home was built by Enos Ives around 1840. His family members were clock makers and were among the first settlers of Bristol. The home still stands today.

CORNER OF PEACEDALE AND BURLINGTON AVENUES. This is an early street scene near the corner of Peacedale and Burlington Avenues. On the left is the house of Enos Ives.

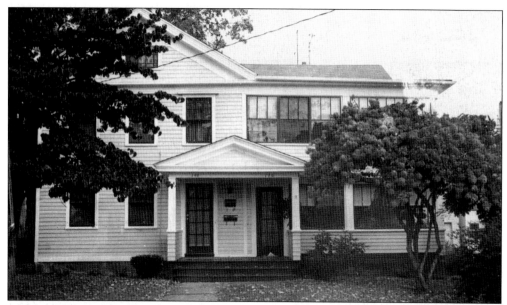

146–148 DIVINITY STREET. This house, built in 1836, is one of the oldest homes on the street. Eliada Tuttle, a farmer, and his wife, Harriet, lived here. His sister, Anna C. Tuttle, the assistant librarian of the public library in Bristol, lived here also. Another family member, Louis B. Tuttle, owner of G. H. Elton Company, a painting and paperhanging business on North Main Street, also lived in the house.

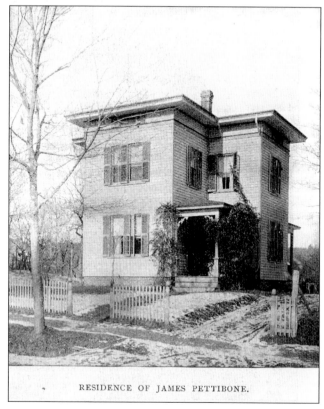

RESIDENCE OF JAMES PETTIBONE.

168 DIVINITY STREET. This home was owned by James Pettibone. Pettibone, who was born in Barkhamsted in 1835, came to Bristol in 1876, after his wife died. His second wife was Anna E. Norton, a teacher in Plymouth, Thomaston, and Bristol. Pettibone was a foreman at Bristol Manufacturing Company. He was a descendant of John Pettibone, one of the original settlers of Simsbury, and Col. Johnathan Pettibone, who served in the Revolutionary War.

50 DOWNS STREET. Ephraim Downs (right) was one of Bristol's first clock makers. He was in business with Seth Thomas, Eli Terry, and Silas Hoadley. The house (above) was built in 1825.

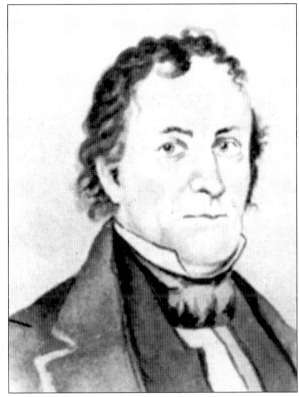

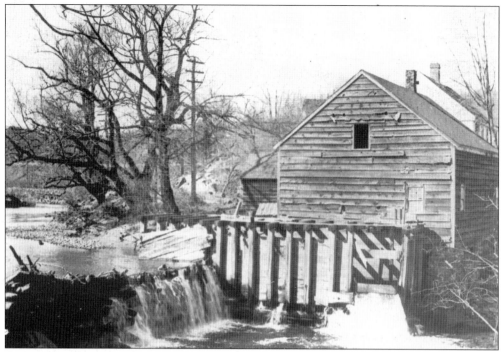

GRISTMILL. This gristmill is located at the east end of Memorial Boulevard. Originally, it was named the Langton gristmill, after its first owner, a Mr. Langton, who built it in 1741. Later it was named Down's Gristmill, when it was owned by Ephraim Downs. In 1921, it was torn down.

FRANKLIN DOWNS. Born in 1824, Franklin Downs was the son of Ephraim Downs. He worked as a clock maker with his father and later became a miller and a dealer in grain. He died on August 24, 1898.

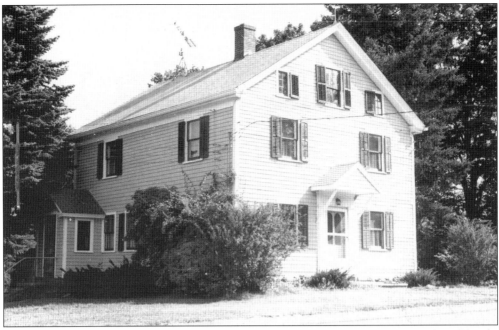

1379 FARMINGTON AVENUE. This house, built in 1820, was first owned by the Lindquist family. In 1908, Lars John Larson and his wife, Lydia, purchased the house and surrounding acreage. Larson worked at Sessions Clock Company. He and Lydia had 12 children.

LYDIA C. LARSON. Lydia C. Larson grew vegetables and raised livestock on her property at 1379 Farmington Avenue. Her son Eric, a carpenter by trade, built a small stand where they sold the vegetables. Eventually, it became known as Larson's Farm.

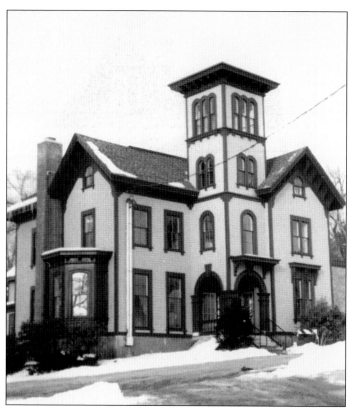

51 High Street.
Samuel Emerson Root (below) was a nephew of Chauncey Ives of Bristol. Root came to Bristol and formed a partnership with Edward Landon. The partners built a factory located on Main and School Streets. Their specialty was clock dials and other clock trimmings. When Root died in 1896, his son-in-law, Edward E. Newell, took over the business. The house (left) was built in 1854 by Joel T. Case and is owned today by the City of Bristol's Youth Services.

131 HIGH STREET. Dr. Frederick Henry Williams (below) was born in 1846 in Pleasant Valley, Barkhamsted. Williams was a medical doctor with a large practice specializing in chronic cases. He was also interested in geology and archeology. He owned a large collection of prehistoric artifacts, which he donated to the Bristol Public Library. His house (right) stood at 131 High Street.

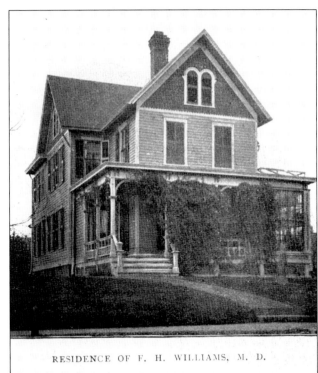

RESIDENCE OF F. H. WILLIAMS, M. D.

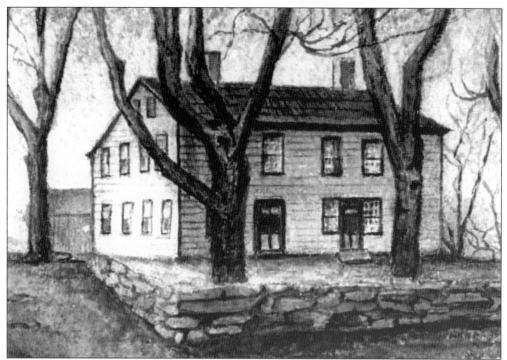

752 HILL STREET. The picture above, from around 1810, shows the house built by Samuel Jones. Jones was a farmer and carpenter by trade and also a charter member of the Franklin Lodge of the Masonic order, instituted in 1819. Many of the Masonic meetings were held at his home in the second-floor ballroom. Later, in 1908, it became the home of Dr. Charles Shepard. Shepard was married to Marguerite Dunbar, daughter of Edward B. Dunbar and Alice Dunbar (née Giddings). The picture below shows the home, today known as the Shepard House.

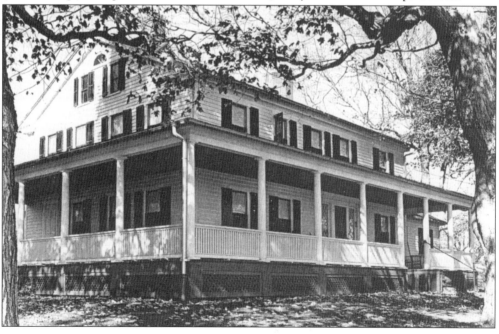

LAUREL STREET. William A. Terry of Bristol took this photograph looking west on North Main Street in 1865. It shows a view of Laurel Street.

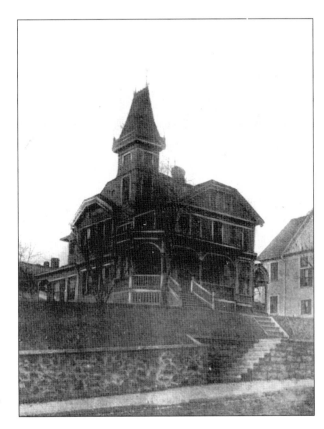

JOEL T. CASE HOUSE. This house was built by Joel T. Case in 1870. The house (right) later became the law offices of Noble E. Pierce and his brother Kendall M. Pierce. Today it is a multifamily home.

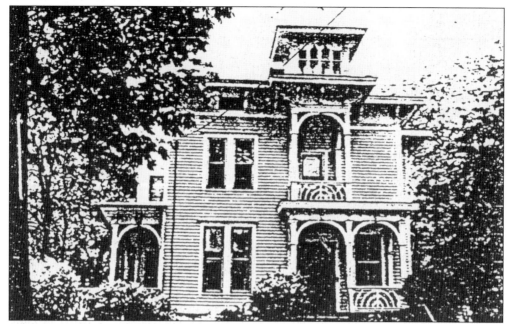

341 MAIN STREET. This house was built by Joel T. Case in 1876 and owned by Harry Ives Bartholomew, son of Harry Shelton Bartholomew and Sabra Bartholomew (née Peck). Harry Bartholomew manufactured paper boxes.

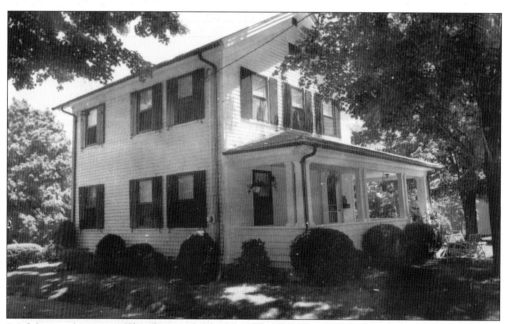

36 MAPLE AVENUE. This house, built in 1850, was originally owned by John Humphrey Sessions. Born on March 17, 1828, Sessions started working at A. L. and L. W. Winston in Polkville. He married Emily Bunnell and, in 1858, entered into a partnership with Henry A. Warner. In 1879, he purchased the Bristol Foundry Company with his son, William E. Sessions, and the company became known as the Sessions Foundry Company. Originally, Maple Avenue was known as Edgewood Street.

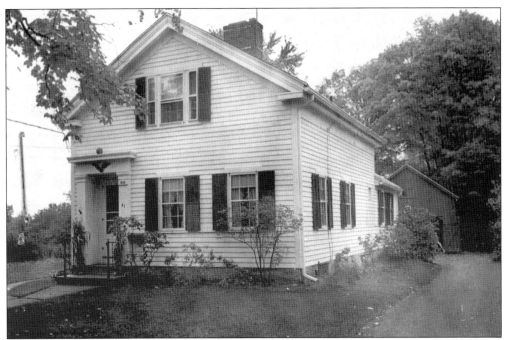

41 MAPLE AVENUE. In 1834, William B. Carpenter came to Bristol from Rhode Island and lived in this house, built in 1843, for 12 years until his death, in 1855. He was a cabinetmaker at first and later made clock cases with Benjamin Ray at Ray's factory near Pierce Bridge. He also worked at the Bartholomew Clock Making Factory in the case department.

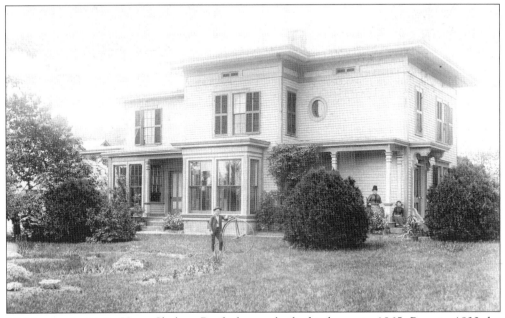

57 MAPLE AVENUE. Harry Shelton Bartholomew built this home in 1865. Born in 1832, he was the son of George Bartholomew and Angeline Bartholomew (née Ives). He worked with his father at the grinding shop on Mill Road (now Warner Street), making table cutlery. He married Sabra Peck in 1860 and had three children, Alice, Harry Ives, and Joseph Peck.

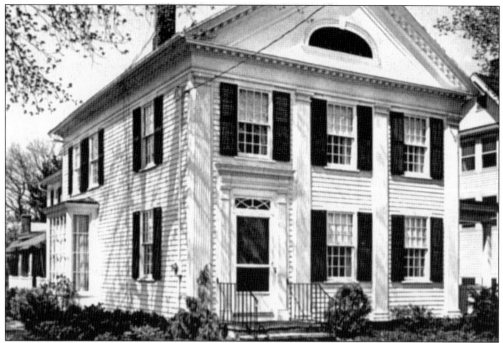

77 MAPLE STREET. Samuel Smith built this house in 1833. Smith was in business with Chauncey Boardman, a clock maker, and kept a store next to the house where he sold the clocks.

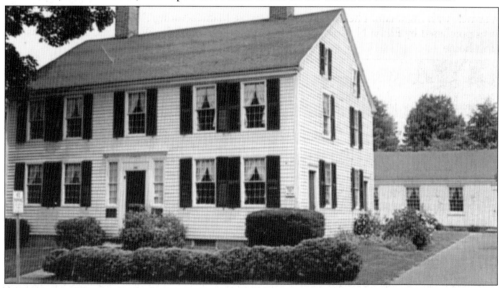

100 MAPLE STREET. Miles Lewis built this home in 1801 for his new bride, Isabinda Lewis (née Peck), daughter of Josiah Peck and Jemima Peck (née Rogers). Lewis was born in 1777 to Abel and Ruth Lewis (née Adams), who owned the Lewis Tavern. Miles and his wife never had children, and their niece, Ellen Lewis Peck, came to live with them. The home stayed in the family until 1952, when Ellen Amy Peck died. Around that time, the newly formed Bristol Clock Museum purchased the home. Today it is the American Clock and Watch Museum, where many of the original clocks made in Bristol are on display. One room in the house has the original wood paneling from the Ebenezer Barns home on the walls.

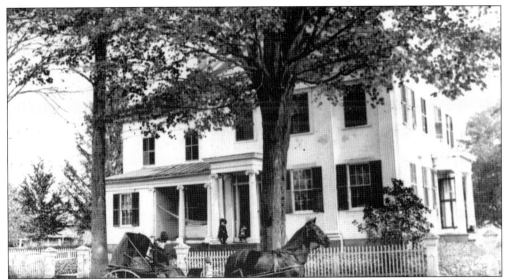

122 MAPLE STREET. Lawson Ives built this house in 1833. He and his uncle Chauncey Ives began making clocks in 1830. The firm was known as C. and L. C. Ives. George Mitchell brought Elias Ingraham, a cabinetmaker, to Bristol, and together they designed a clock case for the Ives Company. By 1836, C. and L. C. Ives Clock Factory was worth $100,000; however, when the 1837 depression came, the company, along with many others, failed. In 1844, Lawson Ives sold his home to Jonathan C. Brown, a clock maker who came to Bristol in the late 1820s from Coventry. Brown, who had worked with Ingraham, purchased land between 1833 and 1834 and became partners with Ingraham. Their company, Forestville Manufacturing Company, did not survive and was purchased by Elisha N. Welch. Brown continued to work for Welch and, in 1860, acquired this home.

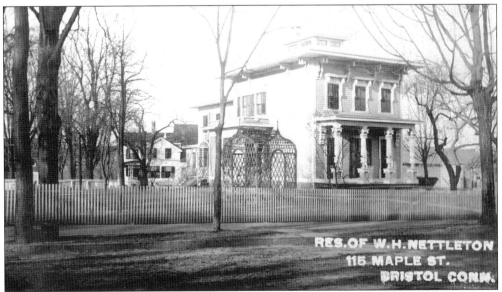

123 MAPLE STREET. This home was the residence of Wilford H. Nettleton, a manufacturer of clock parts. Nettleton was also a major stockholder in the Pequabuck Oil Company and was one of the oldest and best-known residents of Bristol. The home was built around 1860, at which time it was house number 115.

131 Maple Street. This house was originally owned by Walter O. Perkins, an assistant engineer for the Bristol and Plainville Tramway Company. Albert Nettleton, a relative of Wilford H. Nettleton, also resided in this home. When it was built in 1820, it was house number 125.

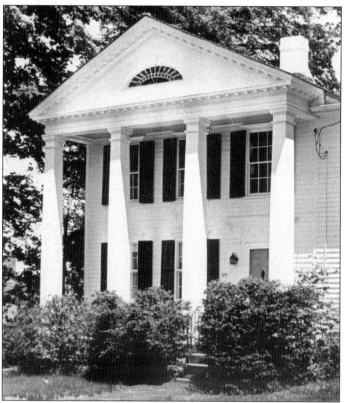

123–125 Middle Street. In 1831, Theodore Terry built this house. He was the son of Samuel Terry and the nephew of Eli Terry, both clock makers. Later, in 1850, it was owned by Henry Mitchell, an attorney and state legislator. Leonard Hayden, the architect who designed the Memorial Boulevard, purchased the home after Mitchell's death in 1888. The home, known as the Terry Hayden House, was moved in 2000 to the back lot and is now office space.

HON. GEORGE MITCHELL.
Hon. George Mitchell, son of
William Mitchell, was born in
Bristol in 1774. He started his
career by opening a general store
on South Street with Thomas
Barns Jr. in 1796. He soon sold
clocks with Gideon Roberts,
an early clock maker. As the
demand for clocks grew, Mitchell
convinced other clock makers to
come to Bristol. By 1835, there
were 16 clock factories in Bristol.
Mitchell had three wives and
12 children. His eldest son,
Julius R., carried on the business.

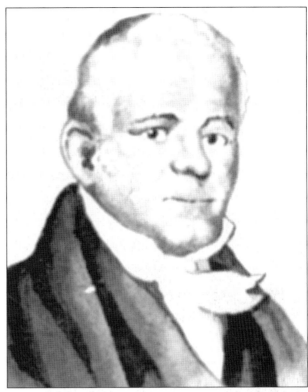

21 NORTH STREET. This home was built in 1830 by Henry Robbins and was lived in by George
Mitchell until his death. It was then purchased by William Goodsell. In 1982, it was dismantled.

77 NORTH STREET. This house, built around 1860, was the residence of Lester Goodenough.

LESTER GOODENOUGH. Born in Burlington in 1820, Lester Goodenough was the son of Ephraim Goodenough. He was the eldest of five children. He finished a three-year apprenticeship, during which he learned wood clock turning at E. K. Jones in Whigville. He came to Bristol in 1837 to work for Chauncey Boardman, finishing clocks. After six years, he went into business for himself, making clock trimmings. Later he partnered with Asahel Hooker in a brass foundry business.

PAUL HUBBARD. Paul Hubbard was born in 1886 to Fred Hubbard and Henrietta Hubbard (née Minor). He was the owner of Hubbard Florist and was the first president of Bristol Nurseries, which he also started. He worked with Alex Cummings Jr. to develop chrysanthemums. This is how Bristol became known as the Mum City. Hubbard died in 1959.

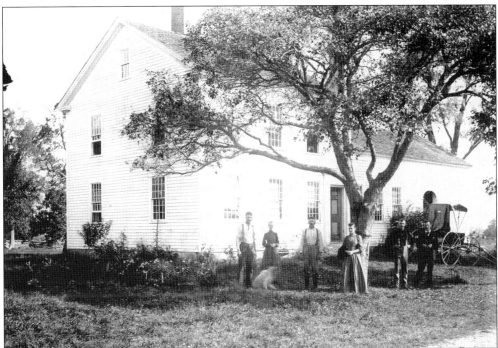

66–68 PINEHURST ROAD. The Hubbard family lived in this house, built around 1860. The house was originally owned by Dotha Darrow, wife of William Darrow. Later the home was owned by the Bird family, pictured in this photograph.

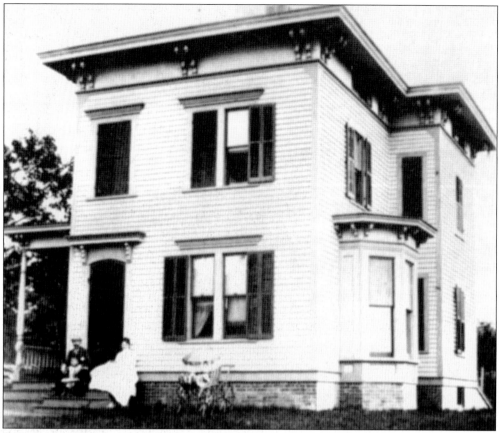

37 Prospect Place. This home was built in 1878. It was owned by M. L. Seymour.

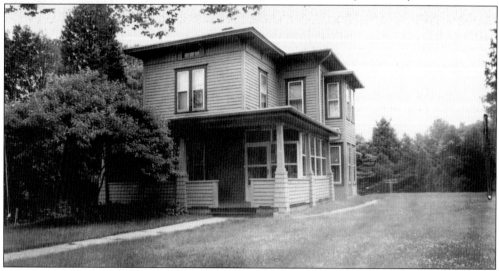

255 Queen Street. John Fingeton, born in Ireland in 1841, came to Bristol with his wife, Mary, and purchased this land from Gad Lee in 1872. The house was built in 1876. In 1881, Fingeton purchased more land from Lee to build a barn. Fingeton was employed by Bristol Brass and Clock Company.

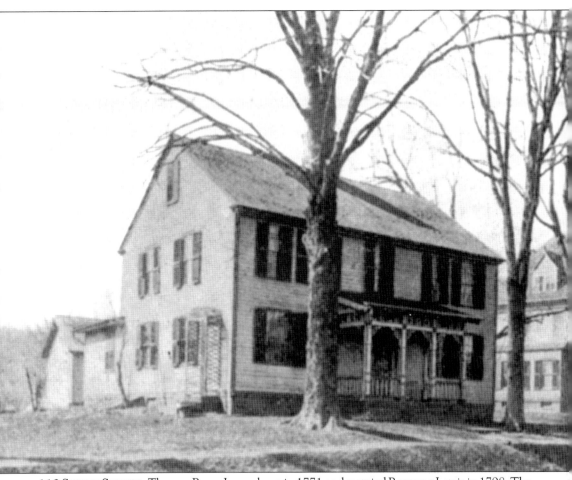

110 SOUTH STREET. Thomas Barns Jr. was born in 1771 and married Rosanna Lewis in 1798. The couple built this home in the early 1800s. They had two children, Eveline, who became the wife of Dr. Charles Byinton, and Alphonso Barns, who married Almira Andrews. Thomas Barns Jr. built a general merchandise store on South Street and then built another building in which he manufactured carriages and wagons. Later his grandson Thomas Barnes, who added the *e* to the Barns name, lived in the house.

CHAUNCEY JEROME. Born in 1793 to Lyman and Sarah Jerome (née Noble), Chauncey Jerome came to Bristol with his wife, Salome Jerome (née Smith), and started his own clock factory after working for Eli Terry and his brother Noble. Jerome moved to New Haven after a fire destroyed his factory. He died in 1868.

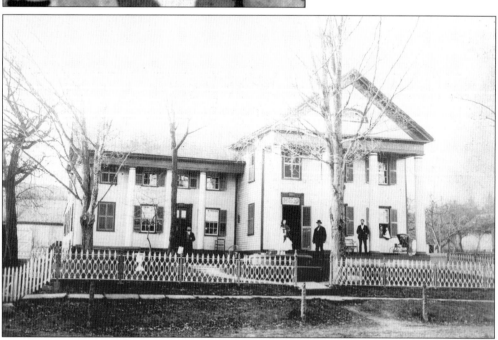

126 SOUTH STREET. This house was built for Chauncey Jerome in 1832. The home, pictured on the cover of this book, is shown as it was before builder Joel T. Case was hired to construct the tower and other additions.

EDWARD BUTLER DUNBAR. One of six siblings, Edward Butler Dunbar was born in 1842 to Edward Lucien Dunbar and Lucinda Dunbar (née Painter). His father, along with Wallace Barnes, owned a clock spring manufacturing company called Dunbar and Barnes. Edward B. worked at his father's business. Upon his father's death in 1872, he and his brothers William A. and Winthrop W. formed the Dunbar Brothers Company. Edward was married to Alice Giddings of Bristol and had three children. He died in 1907.

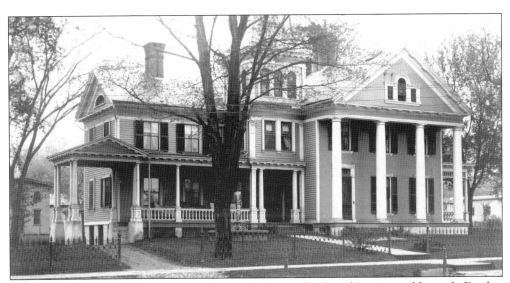

126 SOUTH STREET. After Chauncey Jerome left Bristol, Edward Lucien and Lucinda Dunbar bought this house. At the time this photograph was taken, Edward Butler Dunbar and his wife were living in the house. Today it is owned by the Elks lodge.

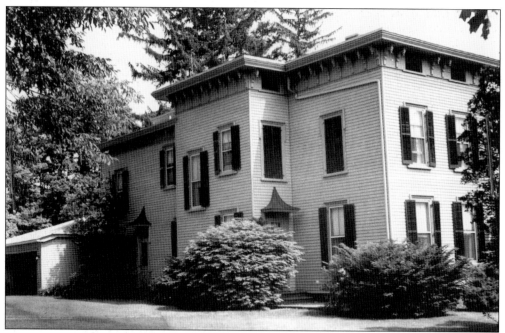

212 STAFFORD AVENUE. This home, built around 1870, was owned by J. Fayette Douglass. Douglass was a clerk at the general store in Forestville, a teacher at Schoolhouse No. 7, and a postmaster.

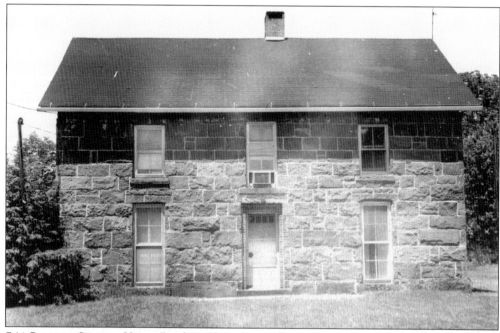

741 STEVENS STREET. Henry Smith and his wife came from England and purchased this property from Asahel Mix. In 1862, Smith built this stone house, which later became a stagecoach inn. The Smiths had seven children. The house is still standing today.

EDWARD INGRAHAM. Born in Bristol in 1830, Edward Ingraham was the only child of Elias Ingraham and Julia Ingraham (née Sparks). In 1859, he joined his father and his uncle Andrew at Elias Ingraham and Company. Upon his father's death in 1885, Edward reorganized the company as the E. Ingraham Company. He married Jane E. Beach of Milford and had three sons. He died in 1892.

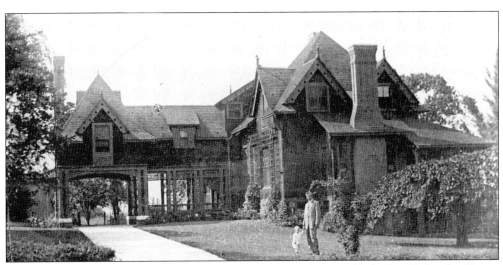

173 SUMMER STREET. The Edward Ingraham Home was destroyed by a fire. Today the Trinity Episcopal Church is built on this land.

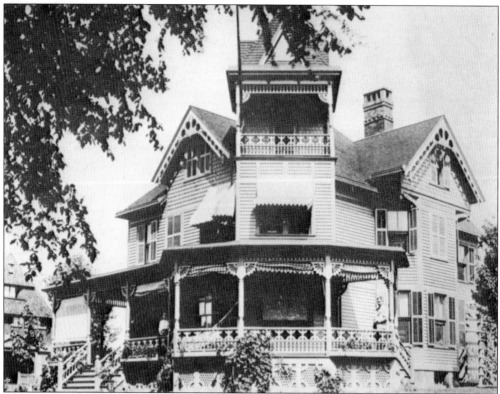

208 SUMMER STREET. This house, built in 1876, was originally owned by Clifford S. Barnes of Burwell and Barnes Company (coal and wood retailers). It later became the home of industrialist Albert Rockwell and his wife, Nettie. This house was designed and built by Joel T. Case.

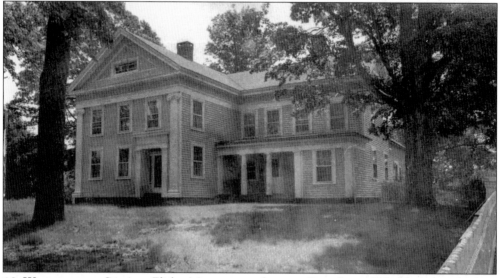

12 WASHINGTON STREET. Elisha Manross was born in Bristol in 1792. He married Marie Cowles Norton in 1821, and they built this house in 1832. Manross became one of the pioneers of brass clock making. Three of his sons, Newton, Elias, and John, were in the Civil War. He died in 1856.

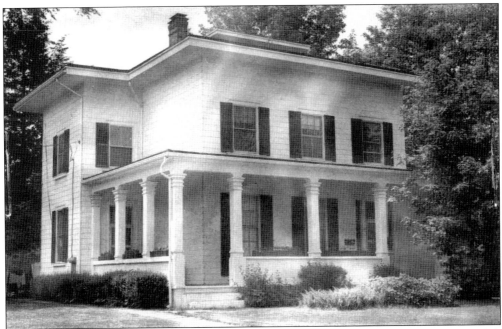

80 Washington Street. This was the home of Elisha Welch, owner of E. N. Welch Manufacturing, who founded the Bristol Brass and Clock Company in 1850. He was married to Jane Buckley of Bristol, and together they had four children. Welch died on August 2, 1887.

211 Washington Street. This house was built in 1845 and was the home of Mark F. Spellman, a farmer.

439 Washington Street. This home was built by Stanley Robertson around 1870. Robertson was one of the original owners of the Robertson Airport in Plainville. The home was later owned by Emil Goranson, an electroplater for Sessions Clock Company, and then by James F. McDermott, a fireman for Bristol.

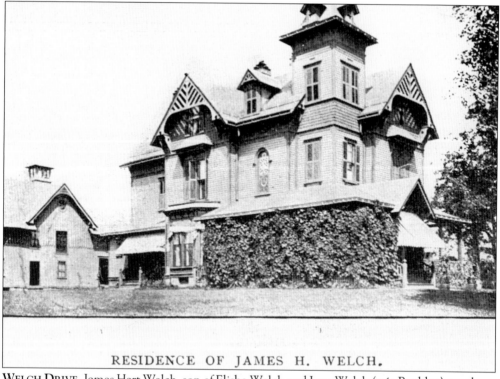

RESIDENCE OF JAMES H. WELCH.

Welch Drive. James Hart Welch, son of Elisha Welch and Jane Welch (née Buckley), was born on July 7, 1840. He worked at his father's E. N. Welch Company and Bristol Brass Company. He became president of both of these companies when his father died. This house was called the Oaks Home. Welch died on January 27, 1902.

ROSWELL ATKINS. The son of Lloyd Atkins and Charity Atkins (née Crampton), Roswell Atkins was born on September 24, 1826. He worked for George W. Bartholomew and then for J. C. Brown and Company. He also worked for Irenus (Priest) Atkins as a toolmaker. He later became a surveyor for Bristol. His first wife was Martha Hart, and his second wife, by whom he had a son, Lloyd, and a daughter, Amelia, was Sarah Barnum. He died in 1903.

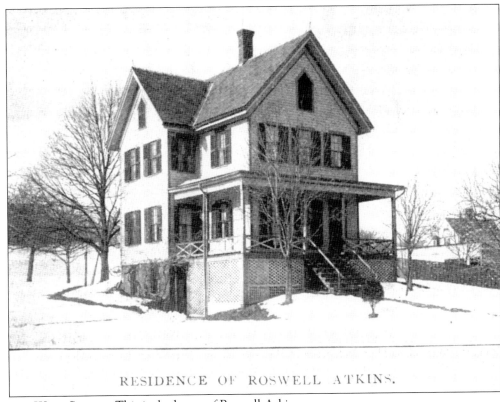

RESIDENCE OF ROSWELL ATKINS.

129 WEST STREET. This is the home of Roswell Atkins.

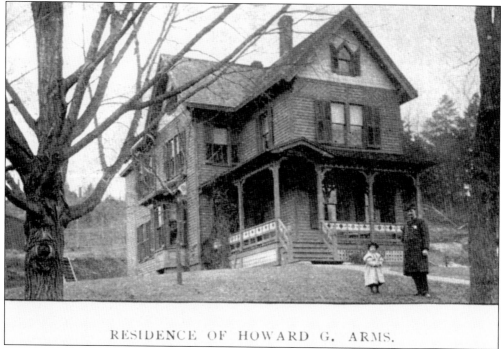

RESIDENCE OF HOWARD G. ARMS.

401 WEST STREET. Howard G. Arms, son of George C. Arms, was born in Moretown, Vermont, on March 28, 1855. He came to Bristol with his family in 1880 and worked in his father's granite and marble business, called George C. Arms Monumental Works. The company made monuments for families such as Hull, Candee, Levitt, and Sessions. Howard became chief of police in 1894, when the police department was established. He also served with the fire department in 1880.

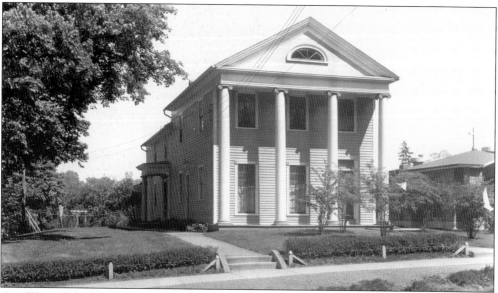

510 WEST STREET. This is another home that Andrew Ingraham lived in. Andrew Ingraham was the brother of Elias Ingraham. This house was built around 1830 and was later torn down to build St. Stanislaus School.

Three

A GROWING
INDUSTRIAL CITY
1880–1889

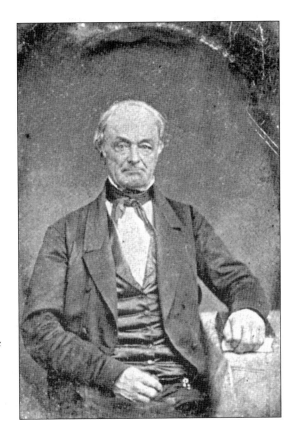

TRACY PECK. Born in Bristol in 1785, Tracy Peck was the son of Lament Peck. At a young age, he held public office. He became an assessor in 1808, a constable in 1809, and first selectman and town clerk by 1816. He married Sally Adams of Litchfield and had eight children. He died in 1862.

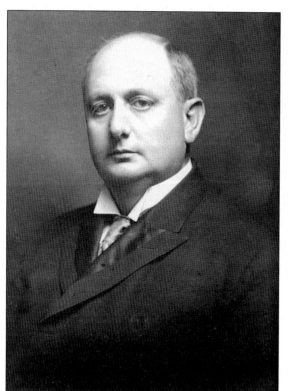

WILLIAM EDWIN SESSIONS. William Edwin Sessions was born in 1857 to John Humphrey Sessions. He attended local schools but did not want to go to college. In 1878, he went to work in his father's trunk hardware factory. In 1879, he and his father took over the Bristol Foundry Company plant on Laurel Street. It became the Sessions Foundry. As the business grew, they purchased 30 acres of land on Farmington Avenue to build a larger factory. This land is where the Bristol Commons Plaza is today. Sessions married Emily Brown in 1878 and had two sons, Joseph B. and W. Kenneth.

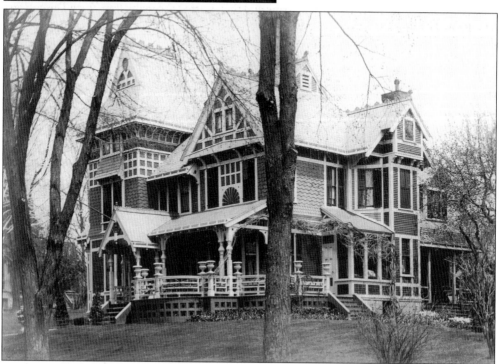

36 BELLEVUE AVENUE. This house was built around 1885 by William Sessions's father. William Sessions and Emily Sessions (née Brown) lived here until 1910, when they built their next home.

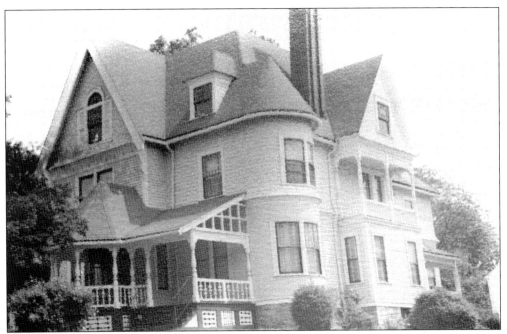

104 BELLEVUE AVENUE. This house was built around 1880 and was first owned by Hon. John Birge, who was born in Bristol in 1853 to Nathan L. and Adeline Birge. John Birge attended local schools and finished at Lake Forest Academy in Illinois. He worked at his father's company, N. L. Birge and Sons, a knitting mill. In 1906, William J. Tracy bought the home. He worked for eight years for the E. Ingraham Company and then started the realty firm Tracy-Driscoll and Company. The house is still a private residence.

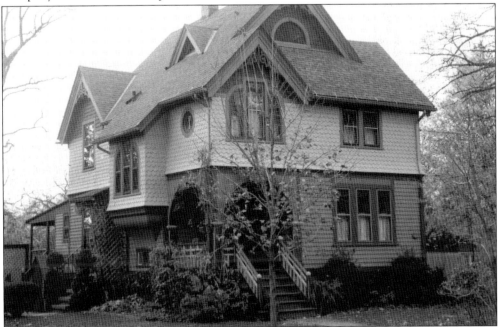

14 BRADLEY STREET. Patrick T. Martin was the building superintendent of Bristol High School. The house was built by Joel T. Case in 1880. It is a Queen Anne–style home with a gable roof.

149 Burlington Avenue. Built around 1885, this home was originally owned by Bernard Kather, who was employed by the Sessions Foundry Company. Many homes in this area were built on land owned by the Sessions family at the same time they built their factory nearby.

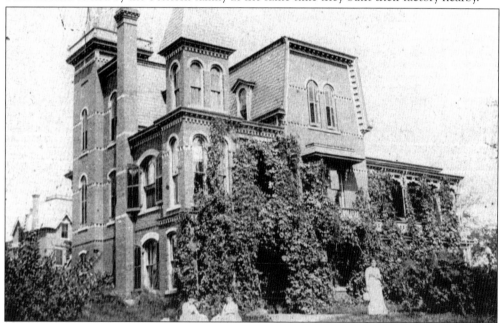

230 Center Street. This home was built in 1880 for Charles Henry Wightman, owner of a steam flour mill in Bristol. When Wightman died in 1882, his widow sold the house and its furnishings to Alfred West, owner of a music store in Bristol. In 1891, West sold the house to Charles A. Treadwell, a manufacturer and inventor for the Horton Manufacturing Company in Bristol. Samuel Joseph Large purchased the home in 1901. Large was the head engraver and designer of the American Silver Company in Bristol. The house was nicknamed Castle Largo and is still referred to by that name today.

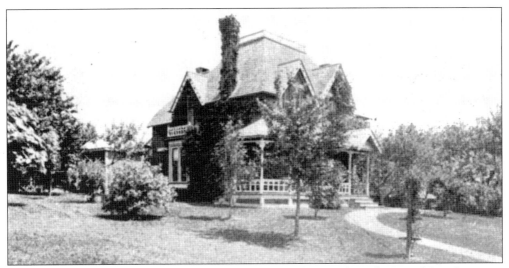

233 CENTER STREET. E. O. Penfield learned the saw-making trade in the Bristol Saw Company shop, the same shop that he later purchased in 1879. His Penfield saw became popular throughout New England. He added more products, which were sold in England and Germany. The house, built in 1880, looks different today and is now a private residence.

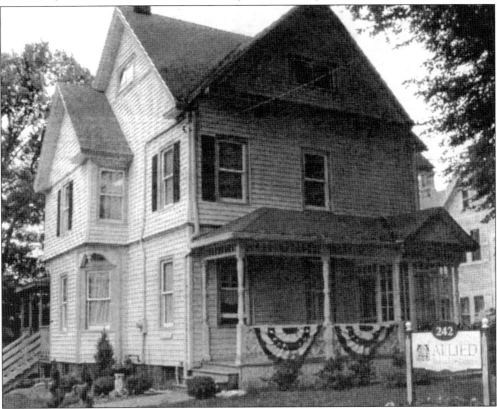

242 CENTER STREET. This Queen Anne–style house was built by Joel T. Case in 1886 for Eunice Richardson (née Terry), widow of Rev. Merrill Richardson. She was the daughter of Eli Terry Jr., who was a clock maker.

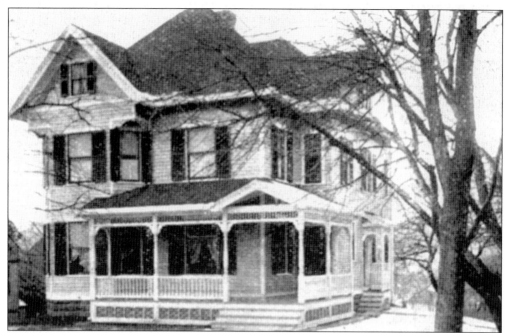

26 ELM STREET. This house was built in 1886 for Hiram C. Thompson. Thompson was born in 1830 and attended local schools until the age of 13, when he went to work in a factory to learn clock making. He became the owner of the H. C. Thompson Company and manufactured clock movements. His factory also made water, gas, and electric meter registers.

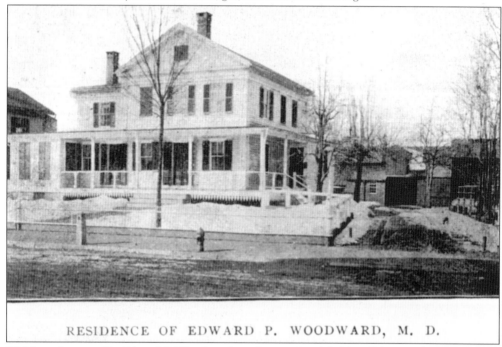

RESIDENCE OF EDWARD P. WOODWARD, M. D.

39 MAIN STREET. Dr. Edward P. Woodward was born in Litchfield on February 5, 1837. He was educated at the Boston University of Medicine. Woodward came to Bristol in 1868 to start his practice. He belonged to a family of physicians.

JOEL TIFFANY CASE. Joel Tiffany Case was born in West Hartland on October 12, 1845. At the age of 19, he moved to Barkhamsted, where he had his first experience with machinery. He ran a sawmill and gristmill. He came to Bristol and went into partnership with John Humphrey Sessions around 1871 to manufacture his invention, the National waterwheel. He also invented a gristmill and manufactured it in 1879. When he sold his business, he started building homes around Bristol. In all, there were about 60, including some prominent ones that were destroyed by fire. Case was married twice and had two sons and five daughters. He died in 1917.

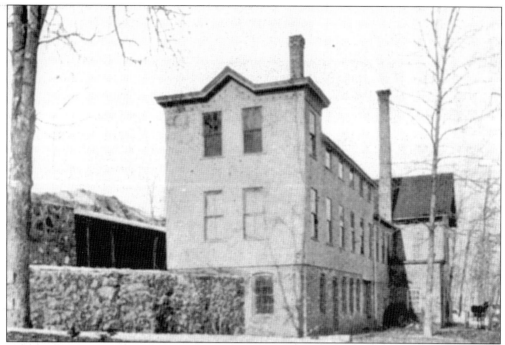

GROVE STREET FACTORY. This was the Joel T. Case factory, at the end of Grove Street. Case used this shop to work on his inventions.

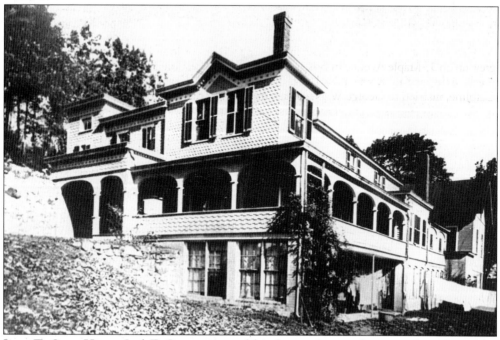

JOEL T. CASE HOME. Joel T. Case converted his factory (pictured at top of page) into his residence. This was the last place in which he lived. It is said that there were 15 exterior doors and a living room that was 50 feet long. In the 1950s, the home was torn down and replaced with new homes, which overlook the top of Page Park.

52 HIGH STREET. Joel T. Case built this house in 1888 for John Humphrey Sessions. Sessions grew up on 37 Maple Avenue in Bristol, was president of Sessions Foundry Company, and owned much of the land in this area. He built several of the homes on Bellevue Avenue. His daughter, Caroline, married to George W. Neubauer, moved into the home around 1905 to live with her mother, Emily Sessions, upon her father's death. Today it is a multifamily residence.

JOHN HUMPHREY SESSIONS. This photograph of John Humphrey Sessions was taken on February 9, 1900.

JOHN HENRY SESSIONS. John Henry Sessions, born in 1849, was the son of John Humphrey and Emily Sessions. He married Marie Woodford, daughter of Ephraim Woodford of Avon, and together they had one child, Albert Leslie Sessions. John Henry Sessions worked in his father's trunk and hardware company. He died in 1902.

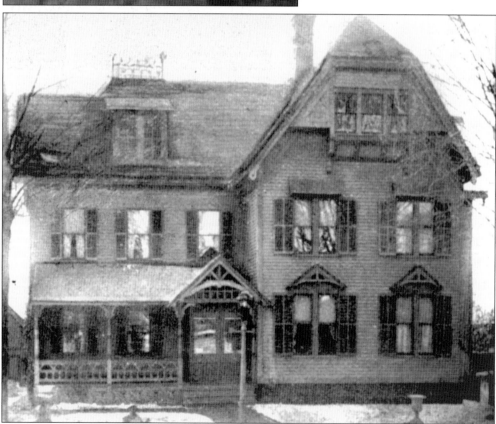

60 HIGH STREET. This home was built in 1882 for John Henry Sessions and his wife, Marie. The house became known as the Bellevue Apartments and is now a multifamily home.

DR. GEORGE SYLVANUS HULL. Born on March 31, 1847, Dr. George Sylvanus Hull was the son of Sylvanus Hull and Forilla Hull (née Clark). He attended local schools and then went to the Connecticut Literary Institute in Suffield to prepare for medical school. After graduating from medical school, he came to Bristol and worked at Dr. J. H. Austin's practice. When Austin died, Hull took over the practice. Hull was a member of various civic clubs. He died on December 4, 1906.

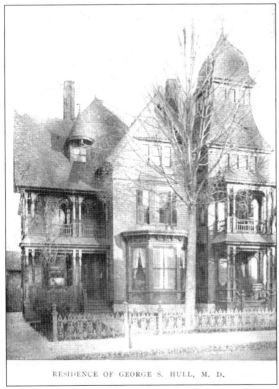

RESIDENCE OF GEORGE S. HULL, M. D.

12 MAIN STREET. Dr. George Sylvanus Hull purchased land on Main Street and built this home.

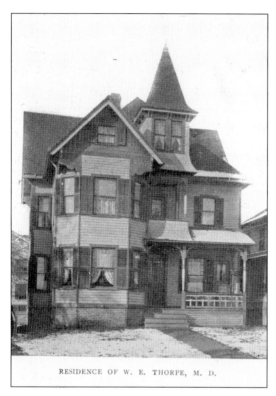

RESIDENCE OF W. E. THORPE, M. D.

67 MAIN STREET. Dr. W. E. Thorpe was born in Southington and was the only son of Judge Elbert E. Thorpe. His family came to Bristol in 1875. Thorpe was an eye-and-ear doctor who practiced out of his home.

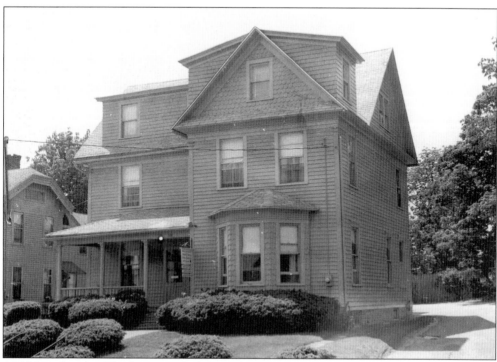

285 MAIN STREET. This home was built by Joel T. Case, who also resided here. It later became the home and business of barber James E. Bride, and then it was converted into apartments and offices.

352 MAIN STREET. This house was built by L. L. Stewart in 1888 for William A. Dunbar. Dunbar was born in 1844 to Edward Lucien Dunbar and Lucinda Dunbar (née Painter). Upon the father's death, William and his two brothers, Edward and Winthrop, took over the Dunbar spring factory, changing its name to Dunbar Brothers. The factory was located on South Street. William Dunbar was married to Josephine Dunbar (née Sharpless), and they had three children, Nettie Louise, Edward Lewis, and William Howard Dunbar.

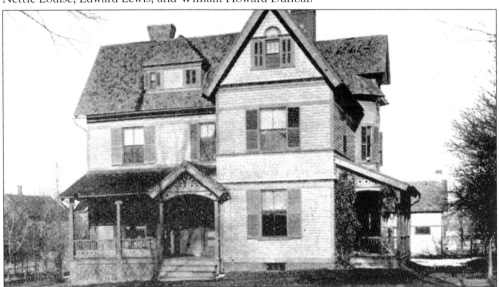

38 PROSPECT PLACE. This was the home of Carlyle Fuller Barnes, son of Wallace Barnes, born in 1852 in Bristol. He was a descendant of Thomas Barns of Farmington. He received business training in the office of the Cheney brothers. After four years, he decided to study music abroad. In 1880, he returned to Bristol to work in his father's factory, the Wallace Barnes Estate Spring Factory. He also played the flute and violoncello (popularly known as the cello) in the Bristol Orchestra. He married Lena Forbes, and they had two sons, Fuller Forbes and Harry Clarke Barnes. He died in 1926.

ADRIAN JAMES MUZZY. Adrian James "A. J." Muzzy was born in Bristol on January 24, 1851, to Henry Muzzy and Mary Muzzy (née Beach). He attended local school and, at the age of 19, went into a copartnership to form W. and A. J. Muzzy, a flour and feed business at the old Downs Mill. In 1873, he opened a men's clothing store on Main Street with Thomas Barbour, under the name of Barbour and Muzzy. By 1876, he had sold his interest and opened a new business called A. J. Muzzy and Company, selling dry goods, millinery, carpets, and household items. He was married to Florence Emlyn Downs, daughter of Franklin Downs and Emeline Downs (née Upson). The couple had three children: two sons who died in infancy and a daughter, Adrienne. Muzzy donated land that became Muzzy Field, where football and baseball are played to this day. He died in 1923.

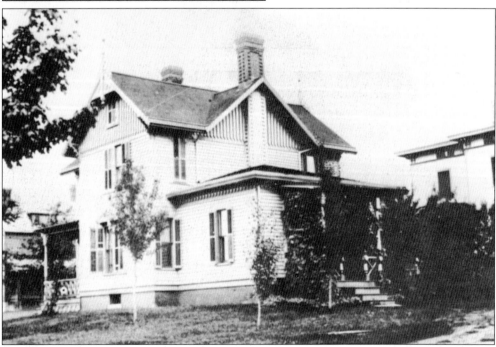

47 PROSPECT PLACE. This house was built in 1880 and was the home of A. J. Muzzy and Florence Emlyn Muzzy (née Downs).

JULIUS R. MITCHELL. Born in Bristol in 1821, Julius R. Mitchell was the son of the Honorable George Mitchell. He worked in the dry goods and men's furnishings business that his father had started. The company name was changed to J. R. Mitchell and Son. He was married to Drusilla Welch, daughter of George Welch and sister to Elisha Welch, the successful manufacturer of clocks. Julius Mitchell died in 1809.

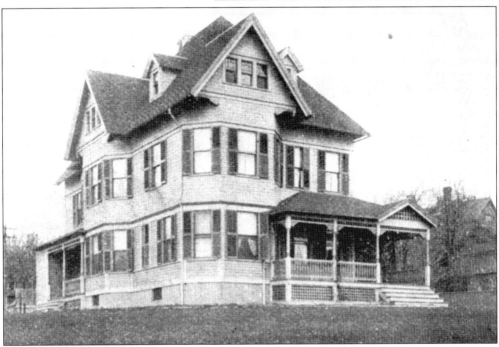

83 PROSPECT PLACE. Shown here is the home of Julius R. Mitchell and Drusilla Mitchell (née Welch).

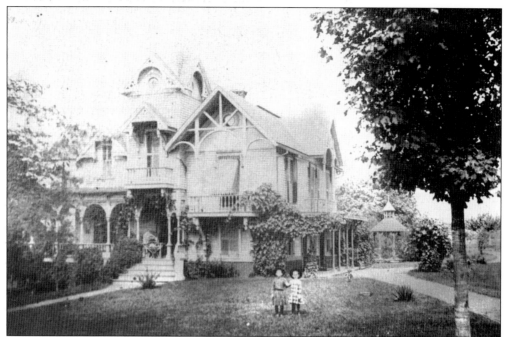

83 PROSPECT PLACE. This house was built by Joel T. Case around 1880 and was destroyed by a fire around 1905. It was resided in by George Merriman, son of Dr. Titus Merriman. George Merriman was married to Ann Peck. In 1825, he started a general store on the north side of Bristol, which sold dry goods, groceries, and drugs. Later his two sons, George and Theodore, continued the business under the name of Merriman Brothers.

60 PROSPECT PLACE. This was the Merriman carriage shed. When the fire destroyed 83 Prospect Place, this building was moved forward to the street and made into a residence.

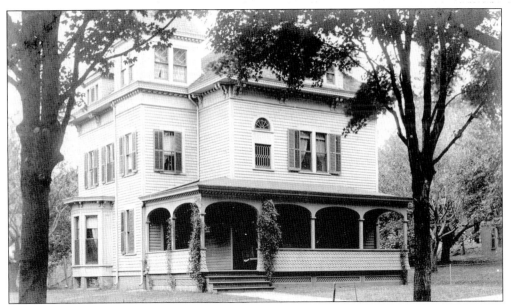

62 PROSPECT PLACE. This was the home of Perry N. Holley, who was a druggist at 238 Main Street and at 49 North Main Street.

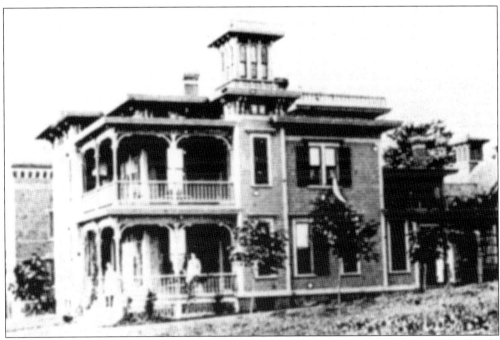

16–18 SPRING STREET. In 1883, Joel. T Case built this house for Edward Duton Rockwell, son of Leander Rockwell and Fidelia Rockwell (née Locke). Edward Rockwell was born in Woodhull, New York, on March 13, 1855. He had two brothers, Albert Fenimore and Frank L., and a sister, May Belle, who married Dewitt Page. The family moved to various locations before they came to Bristol in 1888. Edward worked with his brother, managing their business, New Departure Bell. He married Grace W. Danne in 1883 and had one son, Dale Stanley Rockwell. He left New Departure and became manager of Liberty Bell Company. He died in 1925.

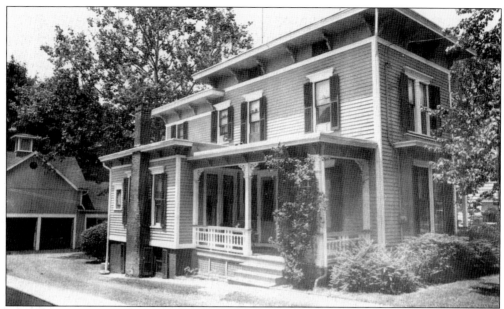

19 SPRING STREET. Joel T. Case built this house in 1881, and Walter E. Strong lived there. Strong was the owner of South Side Market, which sold meat and vegetables. The market was located on 99 Main Street, opposite Water Street.

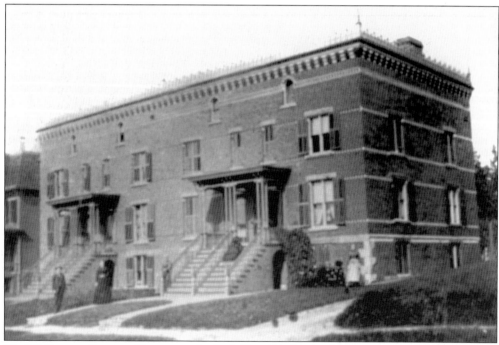

22–28 SPRING STREET. Known as the Joel Case Block, this building was built in 1880 as a four-family apartment house. It was recently restored back to four townhouses.

38 Spring Street. Morse Richtmeyer lived in this house, which was built by Joel T. Case in 1886. Richtmeyer was employed at Ideal Laundry, founded in 1885 on Pearl Street in Bristol. He was married to Lillian E., and they had a son, Morse Richtmeyer Jr.

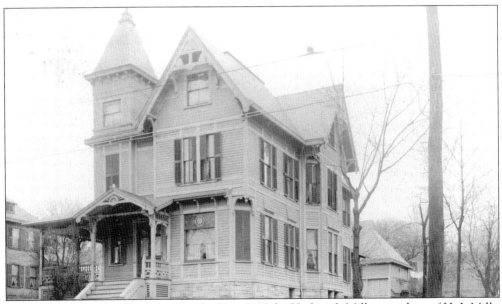

78 Summer Street. This home was built in 1899 for Herbert J. Mills, president of H. J. Mills, located at 149 Church Street. Mills, a nephew of Nancy A. Hitchcock (née Mix), wife of Elder Benajah Hitchcock, entered his uncle's business in 1867. In 1887, Mills and his cousin David Mix leased the business from his uncle, and in 1891, he purchased the company, naming it Mills Box Shop.

MILES LEWIS PECK. Miles Lewis Peck was born on July 24, 1849, to Josiah Tracy and Ellen Lewis Bernard Peck. He was the oldest of six children. His mother, Ellen, was the daughter of Josiah Lewis. Peck's father, Josiah, along with Henry A. Seymour, started the Bristol Trust Company in 1870. Peck married Mary Seymour, daughter of Henry A. Seymour and Electa Seymour (née Churchill), and together they had five children. Peck became president of Bristol Savings Bank and stayed there for 71 years until he died in 1942.

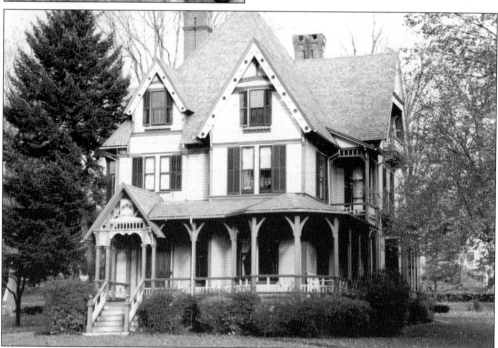

174 SUMMER STREET. Miles Lewis Peck's brother, Theodore Peck, designed this home. It was completed in 1881.

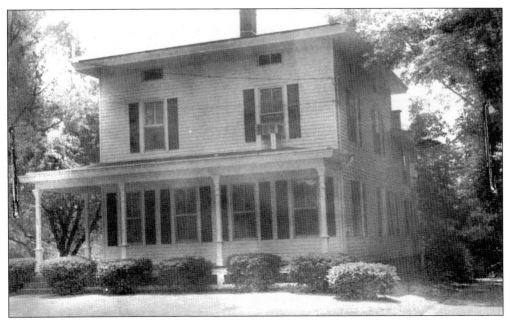

162 WASHINGTON STREET. This was the home of Francis R. Warner, a town selectman. It was built in 1887.

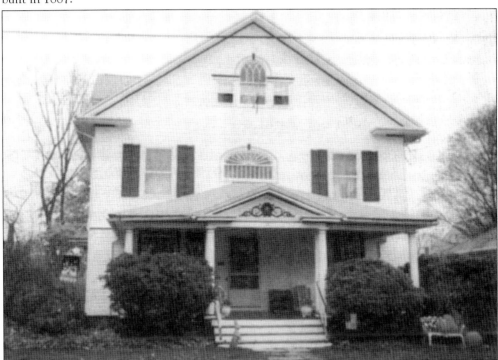

35 WOODLAND STREET. Erwin B. Case lived in this house, which was built by his father, builder and inventor Joel T. Case. The land was part of the 35 acres that Joel T. Case owned. Erwin Case was employed by New Departure Company from its early days in 1889. He became a supervisor and later a director of the employment department. He was also a pioneer of the fire department and an advocate of promoting worker safety and health.

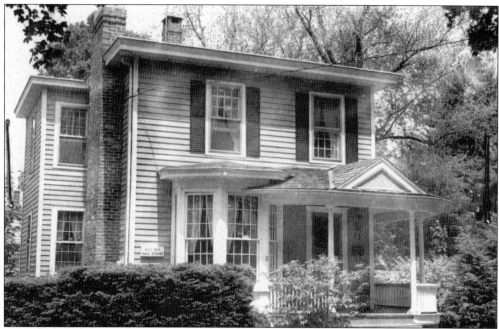

65 WOODLAND STREET. Isaac Stewart built this house in 1885. It was owned by Frank Curtis, who worked at New Departure Manufacturing Company.

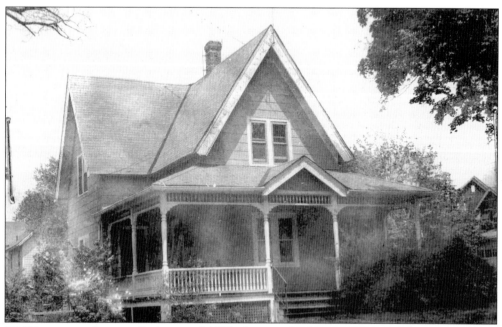

85 WOODLAND STREET. Built around 1885, this was the home of Henry Wilcox. Wilcox was employed by the Sessions Foundry Company.

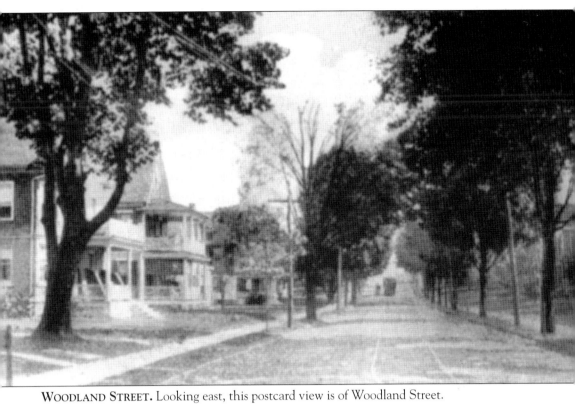

WOODLAND STREET. Looking east, this postcard view is of Woodland Street.

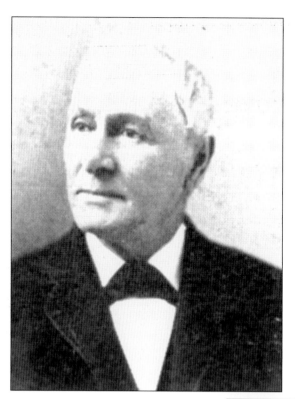

GEORGE WELLS BARTHOLOMEW.
George Wells Bartholomew, born on June 19, 1805, was the son of Asa Bartholomew and Charity Bartholomew (née Shelton). The family lived on Jerome Avenue. At the age of 23, Bartholomew began manufacturing wooden clocks on Warner Street with his cousin Eli. After the panic in 1829, he began making table cutlery and formed the G. W. and H. S. Bartholomew Company. He married Angeline Ives, and together they had eight children. He died in February 1897.

CHARLES TERRY TREADWAY. Born in 1877, Charles Terry Treadway was the son of Charles S. Treadway and Margaret Treadway (née Terry). His mother was from the Eli Terry family of clock makers. Charles Treadway attended Federal Hill School and graduated from Yale in 1900. He went on to become the treasurer at New Departure. At the age of 29, upon his father's death, he became the president of the Bristol National Bank. He was also the chairman for the building committee, which raised money to build a hospital in response to the influenza epidemic in 1918. He died in 1958, having given to Bristol—as his father had—both his time and his talent.

Four

VICTORIAN BRISTOL
1890–1899

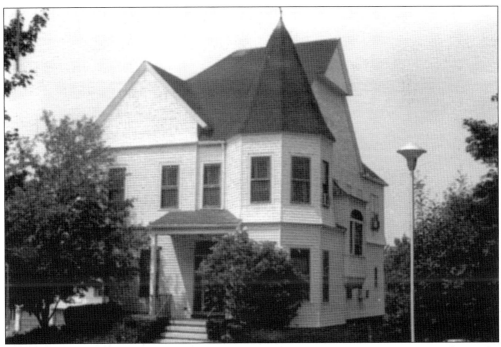

43 BELLEVUE AVENUE. Frank G. Hayward had this home built in 1895. Hayward was the president of the Bristol Manufacturing Company. Jesse Judson, president of the J. M. Judson Company, later owned this home. Today it is a law office.

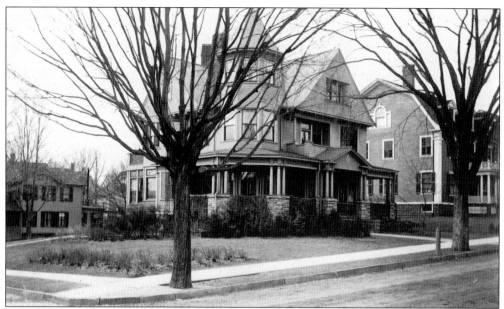

75 BELLEVUE AVENUE. J. R. Holley was vice president of Bristol Brass and Clock Company and a director of the Bristol National Bank, the American Trust Company, the American Silver Company, the Masonic Building Company, and the Bristol Press Publishing Company. Stanley S. Covert was the architect who designed this house, and G. M. Wooster of Forestville built the house in 1898. Fred Lindstead did the masonry on the home.

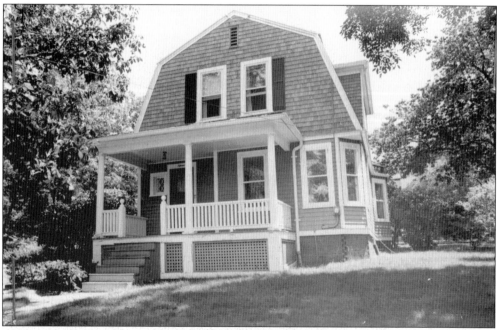

15 BRADLEY STREET. Samuel W. Bradley, owner of all the land in this area, sold 35 acres of land to Joel T. Case in 1896. This home was built on part of that land and was sold to Harold E. Humphrey and his wife, Ethel. Humphrey was a secretary to the general manager of New Departure Manufacturing Company.

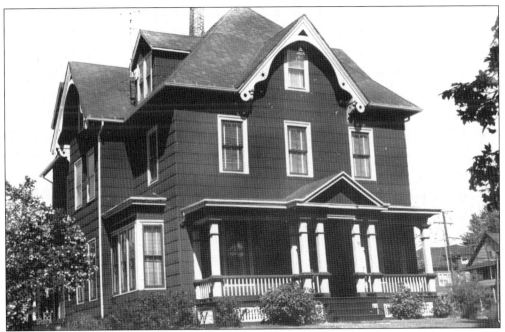

73 BURLINGTON AVENUE. Edward Conlon, who was employed by New Departure Manufacturing Company, owned this house. Joseph Conlon, a relative living with Edward, was employed by Wallace Barnes. The house was built around 1895 by William E. Fogg, a prominent contractor from Bristol. The home was later made into apartments.

174 BURLINGTON AVENUE. Built in 1890, this house was originally owned by the Sessions family. In 1895, it was purchased by P. Schissler, an employee at the Sessions Foundry Company and the New Departure Manufacturing Company.

ELBERT MANCHESTER. Elbert Manchester was the owner of Fern Hill Farm, on Peaceable Street, which was renamed Burlington Avenue in 1915. His farm included some of the land in Nelsons Field, and Pilgrim and Fern Hill Roads to Henderson Street. He married Marietta Hills of Plainville in 1869, and they had two sons, George and Robert, and he later married Mary Blakeslee and had four more children. His home was at 410 Burlington Avenue. He died in 1911.

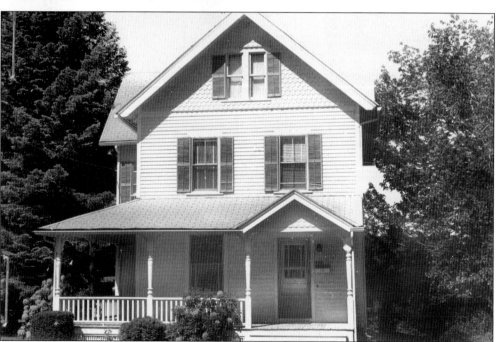

459 BURLINGTON AVENUE. George LeCourse built this house in 1896. George Manchester, son of Elbert Manchester and Marietta Manchester (née Hills), lived here.

613 BURLINGTON AVENUE. Samuel P. Newell originally owned this house, built around 1890. Newell was a dairy farmer and a breeder of Jersey dairy cattle. This house and land stayed in the family until the 1950s.

CHARLES LAWSON WOODING AND 194 CENTER STREET. Charles Lawson Wooding (left) was Bristol's first librarian. He helped with the building of the Bristol Library in 1906 and remained a librarian there for 52 years. His daughter Helen married Rolfe Rowe, a reporter and school truant officer in Bristol. Wooding purchased the house at 194 Center Street (right) from Silas Montgomery, who built it in 1892. This home stayed in the same family for over 100 years.

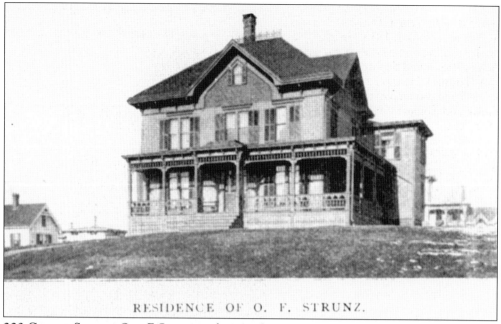

RESIDENCE OF O. F. STRUNZ.

223 CENTER STREET. Otto F. Strunz was born in Germany in 1850 and came to Bristol in 1871. He worked for Elbert Case as a joiner and builder. He purchased a coal business and then started the Bristol Bakery in 1880. He sold his business and became a director for Bristol Electric Light Company and Bristol and Plainville Tramway Company. He built this house around 1890.

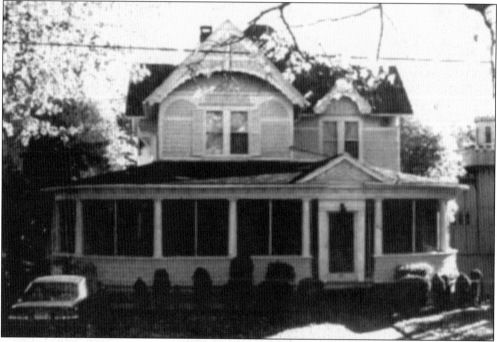

236 CENTER STREET. This house was originally built in 1899 for John S. Curtis. It was then purchased by William F. Stone Jr., who was secretary, treasurer, and general manager of N. L. Birge and Sons, manufactures of men's fine knit underwear. The Stone family lived here until 1941.

GEORGE WHITEFIELD BROWN. Born in Bolton on June 1, 1830, George Whitefield Brown was the son of Seeley Ashley Brown and Sophronia Brown (née Skinner). He came to Forestville in 1845 and was employed by J. C. Brown and Company, clock makers. In 1856, with the assistance of Chauncey Goodrich, he started his own company, George W. Brown and Company Manufacturing, to produce mechanical clockwork toys. He also began making lamp burners, which the Bristol Brass purchased from him in 1858. When his toy business ended in 1880, he went to work for Bristol Brass. He died in 1889.

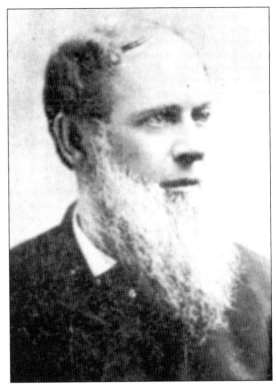

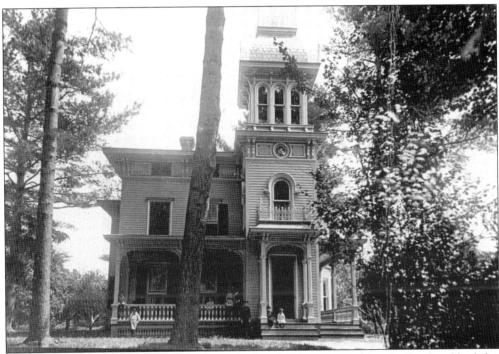

CORNER OF CHURCH AND BROWN STREETS. George Whitefield Brown designed and built his home on the corner of Church and Brown Streets in the 1870s. It was sold by the family in the 1950s and was later torn down for a parking lot.

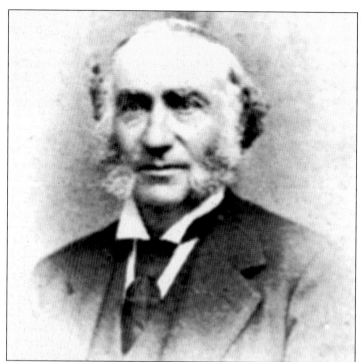

EDWARD OLMSTEAD GOODWIN. Edward Olmstead Goodwin was born in East Hartford and was a descendant of the first settlers of Hartford. He became a lawyer and was one of the founders of the Connecticut Mutual Life Insurance Company. He was in poor health when he came to Bristol in 1848 and became active in the community. He died in 1882.

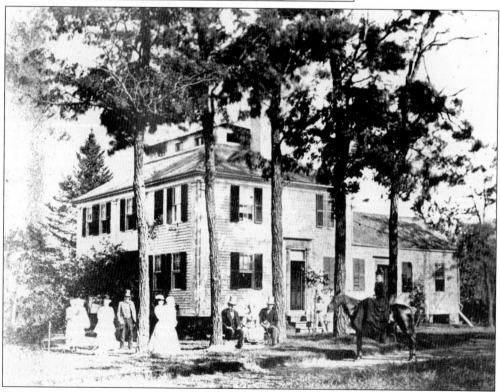

EDWARD O. GOODWIN HOME. Edward Olmstead Goodwin built this home on the corner of Goodwin and Queen Streets after arriving in Bristol. Goodwin Street was named in his honor.

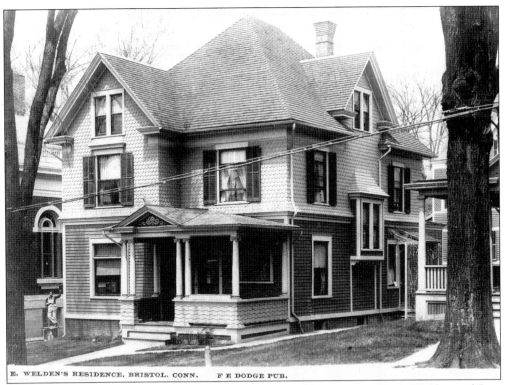

E. WELDEN'S RESIDENCE, BRISTOL. CONN. F E DODGE PUB.

15 HIGH STREET. This was the home of Mortimer E. Weldon, owner of S. A. Weldon and Son, a dealer in paints, oils, and glass. His business was located on 199 Main Street.

20 HIGH STREET. Built in 1890, this was the Trinity Church rectory. The church, which was destroyed by fire in 1949, was located next door. Today it is a private residence.

23–25 HIGH STREET. Originally, this was the home of William M. Curtis, a physician around the 1890s. It then became a private residence until it was purchased by a group home.

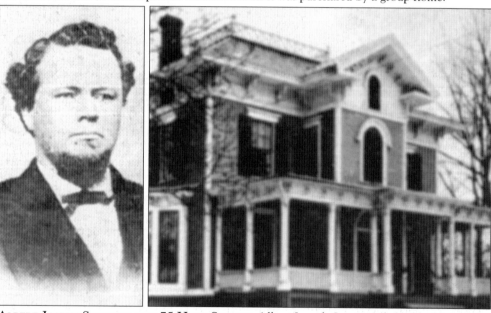

ALBERT JOSEPH SESSIONS AND 75 HIGH STREET. Albert Joseph Sessions (left), brother of John Humphrey Sessions, was born in 1834. In 1857, at the age of 23, he and his brother Samuel W. manufactured trunk trimmings in Southington. In 1862, the business moved to Bristol. Upon Albert's death in 1870, the business was acquired by his brother John. The home of Albert J. Sessions is pictured on the right.

JOHN JOSEPH JENNINGS. John Joseph Jennings was born in Bridgeport in 1855 to Rev. William Jessup Jennings and his wife. He came to Bristol in 1876 and became principal of School District No. 1. He studied law at Samuel P. Newell's firm, married Newell's daughter Elizabeth Newell, and had two sons. He died in 1900, at the age of 45.

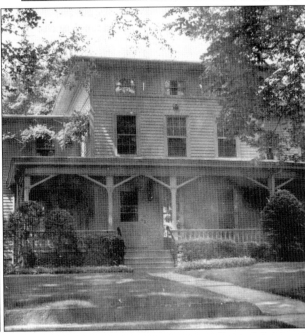

SAMUEL P. NEWELL AND 89 HIGH STREET. Born in 1823 in Farmington, Samuel P. Newell (left) was the son of Roger Samuel Newell. He studied law at Yale University and opened his practice in Bristol. He married Martha J. Brewster, and together they had five children. The 1893 house (right) was the Newell residence. Daughter Elizabeth and her husband, John Joseph Jennings, along with their sons, lived here after Samuel died in 1888.

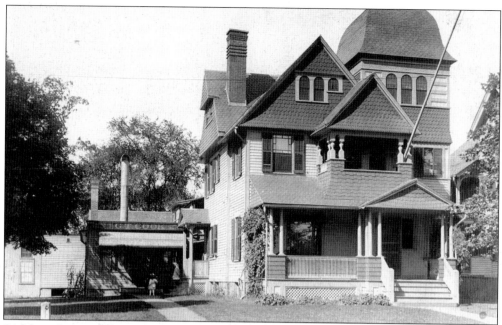

81 MAIN STREET. This is the home of George T. Cook. His G. T. Cook Bakery was attached to the house. The house no longer stands.

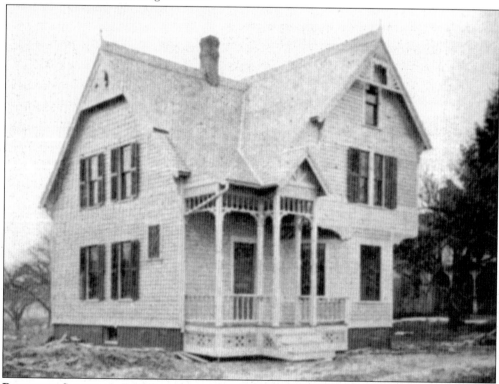

PONDVIEW STREET. A. F. Williams's home was located off Pound Street, going north on Pondview Street, which no longer exists. A. F. Williams manufactured the Monitor incubator and brooder, which were sold all over the world. His factory was located on Race Street.

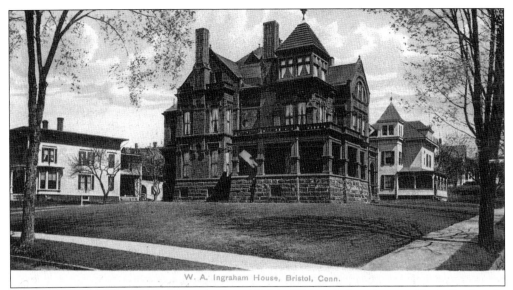

W. A. Ingraham House, Bristol, Conn.

72 Prospect Place. This house was built in 1892 for Walter A. Ingraham and his wife, Amelia Ingraham. Ingraham was the son of Edward I, brother to William and Irving Ingraham and grandson to Elias Ingraham, the founder of the Ingraham Clock Factory. When Edward I died in 1892, Walter became president, Irving became vice president, and William became secretary and treasurer of the company. Walter had one son, E. Morton Ingraham.

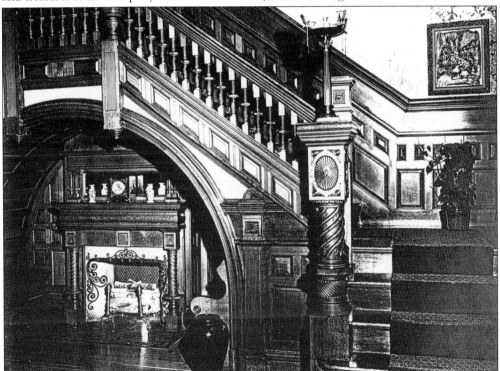

Foyer. This was the foyer in the 72 Prospect Street house. Notice the woodwork around the alcove, where there is a bench to sit next to the fireplace. This home was originally heated by an underground passage from the Ingraham Factory on North Main Street.

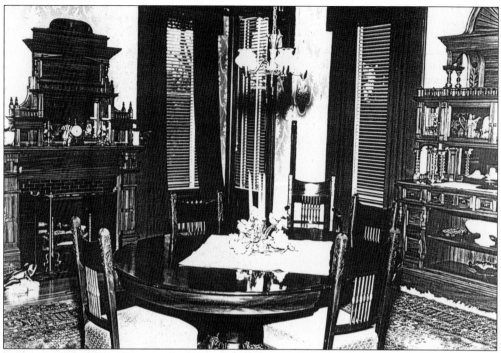

DINING AREA. This photograph shows the decorative wood cabinetry and fireplace in the Ingrahams' dining area.

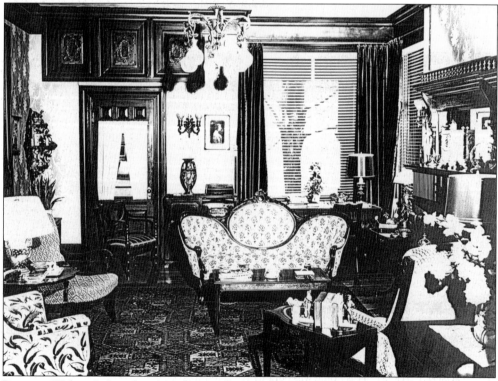

PARLOR. Walter A. Ingraham's parlor was decorated in Victorian décor.

JAMES HANNA. Born in Ireland in 1848, James Hanna came to the United States in 1854 to live in Hebron. After the Civil War, he moved to Bristol and started a harness business. He also organized the Hook and Ladder Company in 1872 and was the chief engineer. He married Mary Fieft of Terryville in 1878.

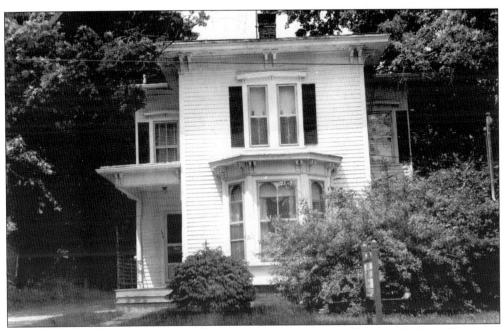

149 PROSPECT STREET. This home was built in 1892 and was originally owned by James Hanna.

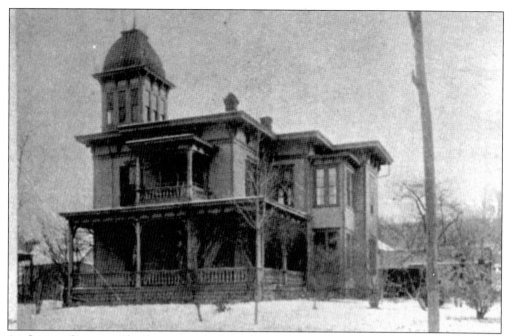

94 SOUTH STREET. This home was built around 1890 and was resided in by Winthrop W. Dunbar, the oldest son of Col. Edward L. Dunbar, founder of Dunbar Spring Manufacturing in Bristol. When his father died in 1872, Winthrop and his two brothers, Edward B. and William A., formed Dunbar Brothers Company. Winthrop married Sarah Wheeler in 1862, and together they had a son, Charles, and a daughter, Alice. Alice married Carlos V. Mason, the founder the C. V. Mason Real Estate and Insurance Company that is still in business today. This home is now apartments.

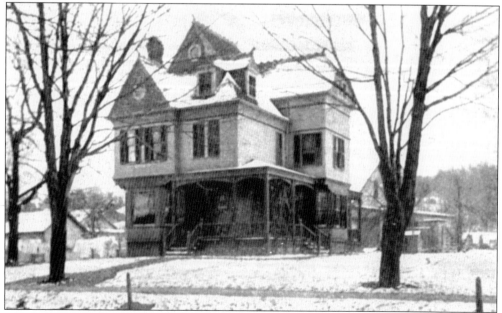

100 SOUTH STREET. This was the home of Charles E. Dunbar, son of Winthrop Dunbar and Sarah Dunbar (née Wheeler). Dunbar was employed in his father's business.

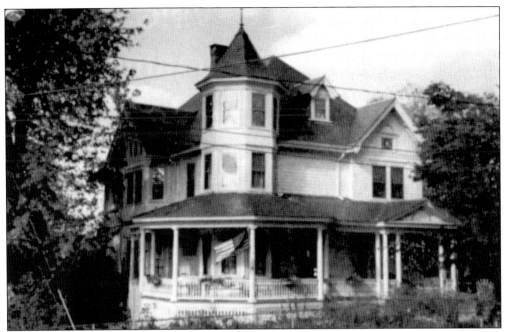

121 SUMMER STREET. This home was built around 1890 and was owned by Elbridge S. Wightman. Wightman owned a distillery in the 1830s that provided brandy to the local taverns. He married Nellie S. Wightman.

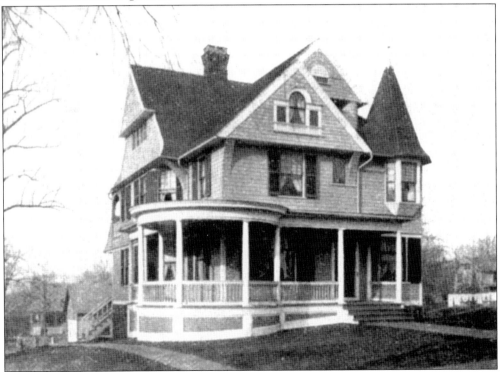

131 SUMMER STREET. Originally the home of W. H. Bacon, this house was built around 1890. It was later owned by George S. Hall.

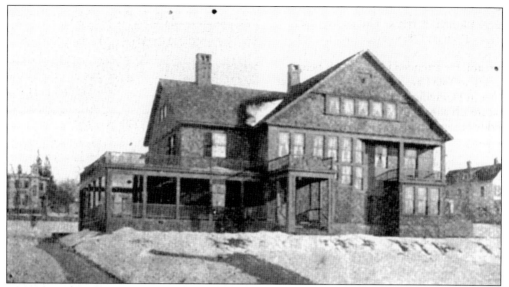

156 SUMMER STREET. This 25-room home was built in 1890 and was heated by the Ingraham Factory. It was resided in by William S. Ingraham, son of Edward Ingraham I and Jane E. Ingraham (née Beach). William was the general manager of the E. Ingraham Company for 40 years. He married Grace Seymour, daughter of Henry Seymour and Electa Seymour (née Churchill). The Ingrahams had three children.

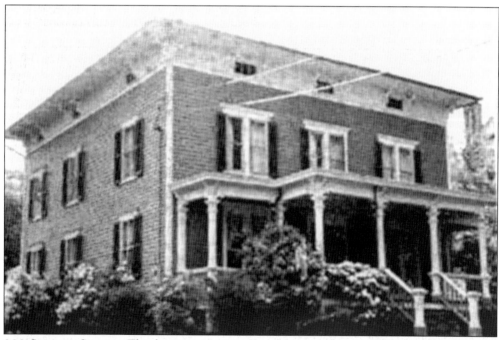

200 SUMMER STREET. This house was originally built around 1890 for Leverett G. Merrick, a prominent grocer in town who owned two separate stores. His wife continued to live here after her husband's death in 1916. Marvin Edgerton, a proprietor of the Penfield Saw Works on Riverside Avenue, later lived here.

EPAPHRODITUS PECK. The son of Josiah Tracy Peck and Ellen Peck (née Lewis), Epaphroditus Peck was born in 1860 in Bristol. He attended local schools before going to Yale Law School. His practice was first in Plainville and then in Bristol. He wrote a history of Bristol and also helped Eddy N. Smith with his book on the history of Bristol. He died in 1938.

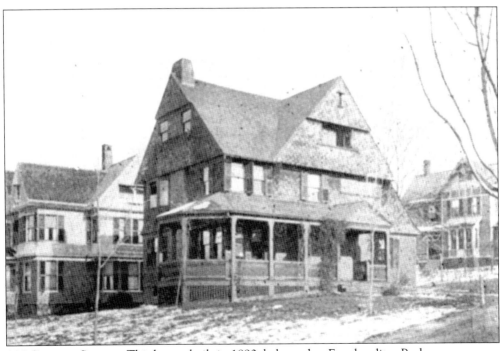

220 SUMMER STREET. This home, built in 1890, belonged to Epaphroditus Peck.

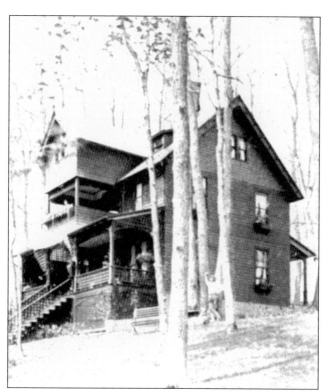

WEST STREET COTTAGE. This cottage was erected in 1888 as a summer residence for Helen Atkins-McKay, daughter of Bristol clock maker Elisha Welch. She purchased 16 acres of land from the Tracy Driscoll estate on West Street, across from where she and her six younger siblings grew up.

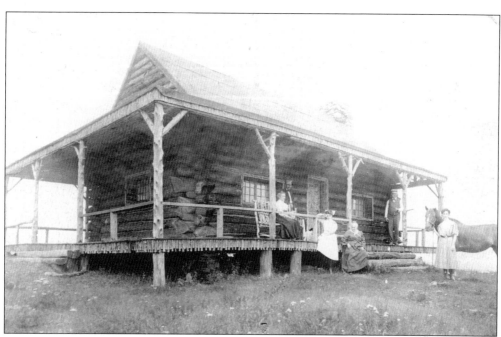

WEST STREET CABIN. Helen Atkins-McKay also had this log cabin built on Fall Mountain.

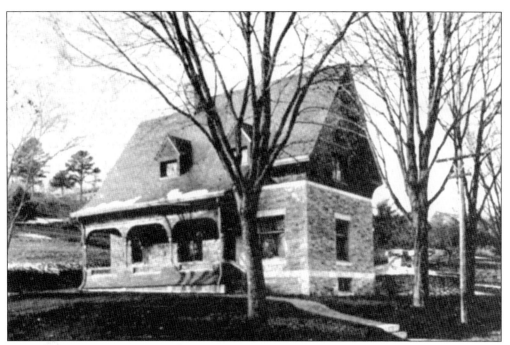

321 WEST STREET. In 1886, Helen Atkins-McKay had this lodge built for her superintendent. It was constructed with the same stone that was used to build the Brightwood Hall mansion. It is a private residence today.

193 WOODLAND STREET. Built around 1890, this house belonged to Roger Mills, son of Herbert J. Mills, owner of H. J. Mills, which manufactured paper boxes. Roger Mills was vice president of H. J. Mills. Roland T. Hull, a mechanic superintendent with American Silver Company, lived here later.

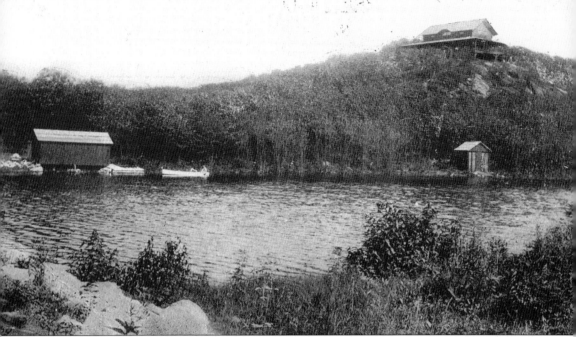

BUNGALOW AND LAKE AT INDIAN ROCK, BRISTOL, CONN, OWNED BY C. F. BARNES.

501 WOLCOTT STREET. Carlyle Fuller Barnes and his wife, Lena, built this summer home, called Indian Rock. The pond was built on the historic Morgan Swamp, named after Morgan, a Tunxis Indian killed by two early settlers. Today the property is the Environmental Learning Center, which provides programs for children.

Five

EARLY 20TH CENTURY
1900–1919

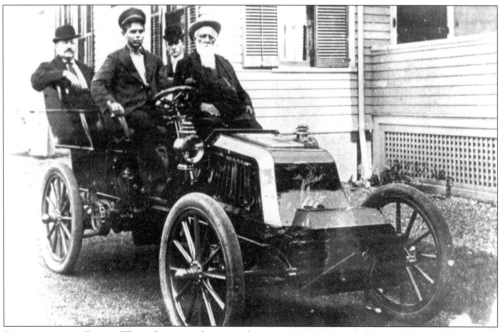

READY FOR A RIDE. This photograph was taken in 1904. From left to right are (first row) Robert H. Manross and Elija Manross; (second row) Mathew Dalton and William Holden.

ALBERT LESLIE SESSIONS. Albert Leslie Sessions was the only son of John Henry Sessions and Marie Sessions (née Woodford). He went to the Federal Hill School and then graduated as a mechanical engineer in 1892. He became a partner in the trunk hardware business after his father died. In 1902, he and his uncle William E. Sessions purchased the E. N. Welch Manufacturing Company and changed its name to Sessions Clock Company. He married Leila Beach, and together they had three children. He died in 1937, leaving his son Paul B. Sessions to be president.

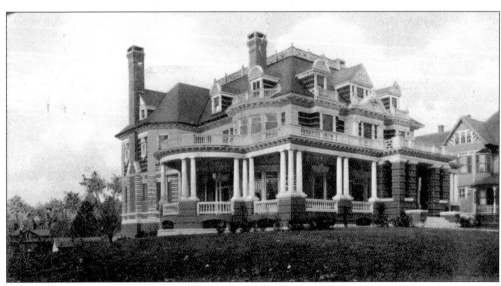

25 BELLEVUE AVENUE. Built in 1903, this was the home of Albert and Leila Sessions. It was nicknamed the Wedding Cake House. Today it is the DuPont Funeral Home.

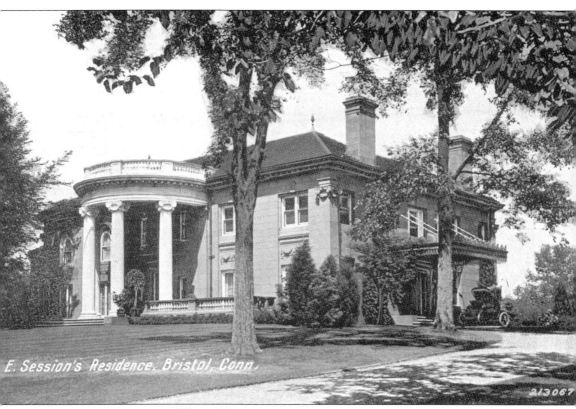

E. Session's Residence, Bristol, Conn.

213067

50 BELLEVUE AVENUE. William Edwin Sessions was living at 36 Bellevue Avenue when he purchased this adjacent home and land from Nathan L. Birge in 1906. Sessions had the house torn down and built this mansion, called Beleden. It was designed by architect Samuel Brown of Boston, and it took four years to build. The estate required 18 servants to care for the house, formal gardens, English garden, pool, greenhouses, grape arbors, and vegetable gardens. Sessions lived here until he died in 1920.

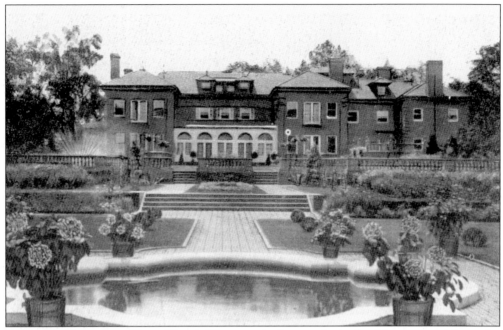

50 BELLEVUE AVENUE (REAR VIEW). This view looking at the back of the mansion shows the Beleden garden.

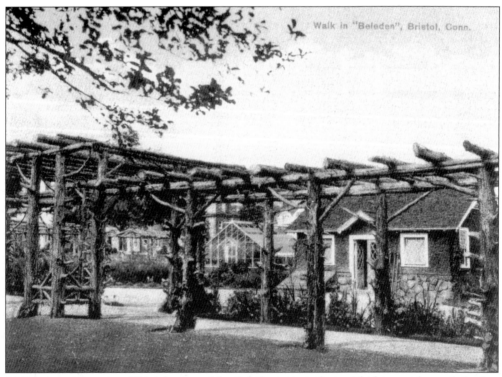

50 BELLEVUE AVENUE. This is a view of the Beleden grape arbors with the greenhouse in back.

BELLEVUE AVENUE. This is a street scene of the lower part of Bellevue Avenue. On the left is the Albert Sessions home, followed by the George W. Mitchell home.

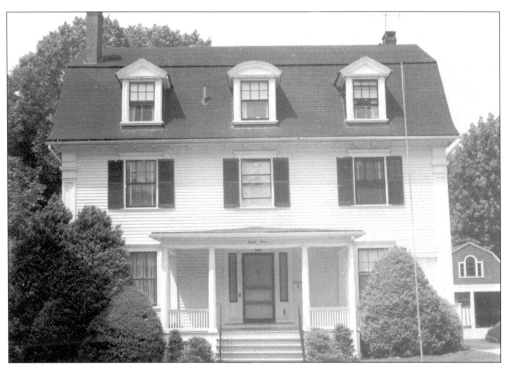

83 BELLEVUE AVENUE. This house was built in 1902 and was resided in by Wyllys Carpenter Ladd, who was born on July 6, 1858, to James E. Ladd and Henrietta Ladd (née Carpenter). Ladd grew up on Jerome Avenue and married Edith Irene Barnes, daughter of Wallace Barnes and Eliza Barnes (née Fuller). He was a manufacturer of clock bells and light hardware.

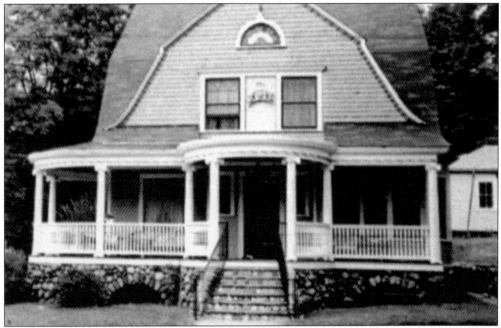

91 BELLEVUE AVENUE. Dewitt Page was born in Meriden in 1869. At the age of 22, he started working at New Departure Bell Company as a shipping clerk. Working for Albert Rockwell, he worked his way up in the company and became general manager. He married Rockwell's sister Mae, and they had one daughter. Judge William Malone lived in this house after the Pages built their mansion on Grove Street.

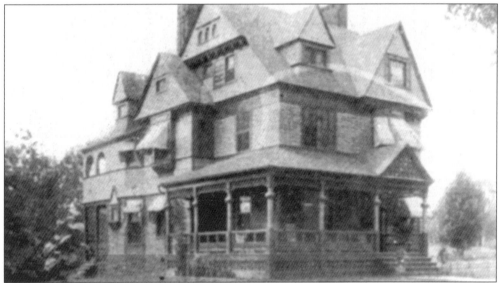

61 BELLEVUE AVENUE (ORIGINALLY 75 BELLEVUE AVENUE). This was the home of Charles Seth Treadway, born in 1848 to Charles Treadway and Emily Treadway (née Candee). Treadway became a banker and helped organize Bristol National Bank in 1874. He married Margaret Terry, daughter of Andrew Terry, and they had two children. He then married Lucy Townsend and had four more children. He died in 1905. The home was torn down, and the Nursing Care Center Convalescent Home is now there.

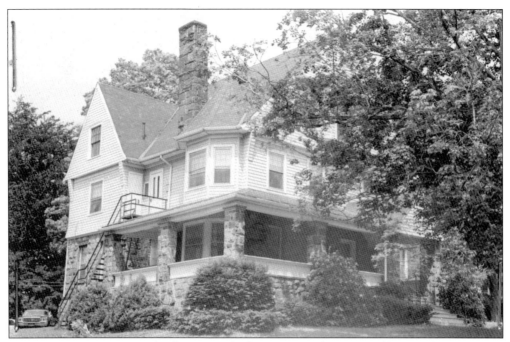

101 BELLEVUE AVENUE. This house was built in 1902 and was owned by Joseph B. Sessions, son of William Edwin Sessions. Joseph Sessions worked in many areas of the Sessions Foundry Company, starting as a pattern clerk and later holding the offices of treasurer, vice president, and president. He was also a director of the Sessions Clock Company.

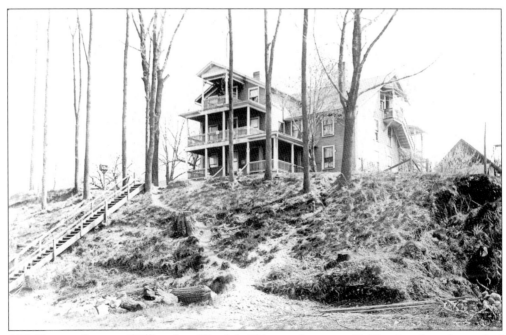

208 CENTER STREET. William Lee Wey left China and came to California, where he worked on the railroads with his cousin. They both escaped and arrived in Bristol. Wey owned the Northside Laundry. This house no longer stands.

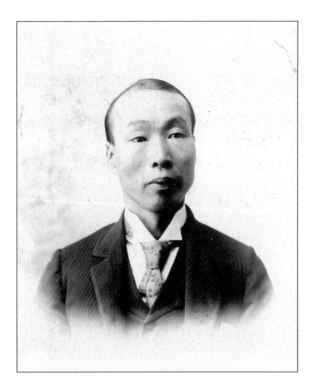

WILLIAM LEE WEY. William Lee Wey designed a special press to iron shirt collars like the one he is wearing here. His laundry business was the only place where this was done.

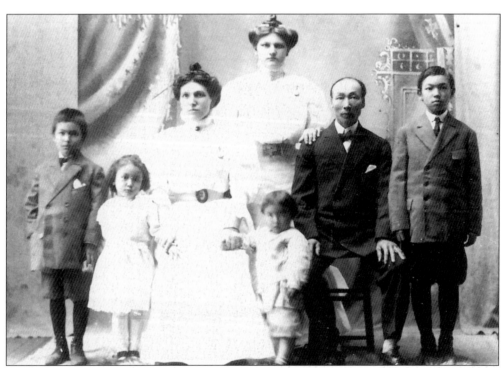

WEY FAMILY, C. 1910. Pictured from left to right are William Jr., Elsie, Eva, George, William, and Howard Lee Wey. In the back is a friend of the family.

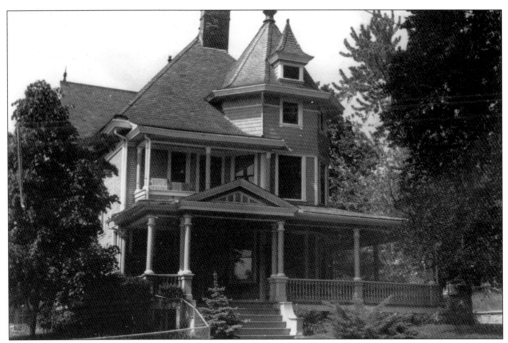

209 Center Street. This was the home of William A. Kimball, who was a purchasing agent for New Departure Manufacturing.

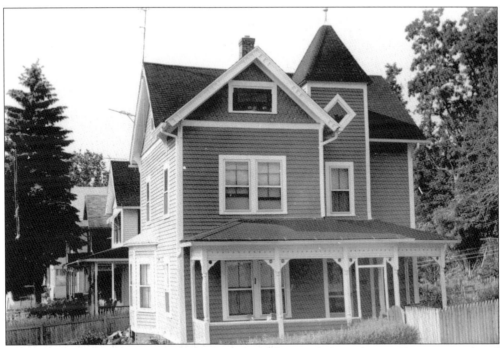

57 Chestnut Street. Built in 1900, this was the home of Howard King. King was employed at New Departure Manufacturing. Later, Joseph Lowicki, an employee of the American Silver Company, lived here.

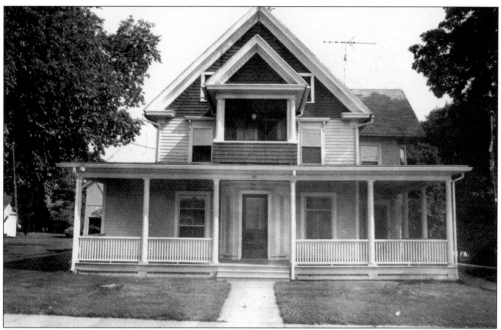

138–140 DIVINITY STREET. This home was built around 1900 and was owned by Henry Roy, an employee of E. Ingraham Company. Fred C. Talmadge also lived here.

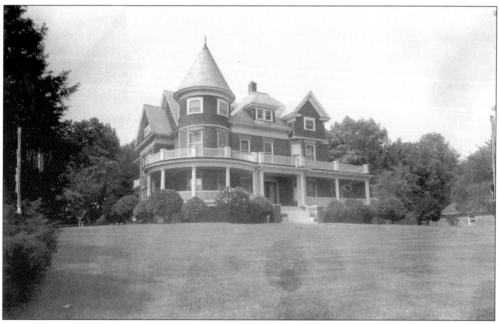

361 DIVINITY STREET. In 1915, this Queen Anne–style home was built and owned by William Burns, a bricklayer, and his wife, Margaret Burns.

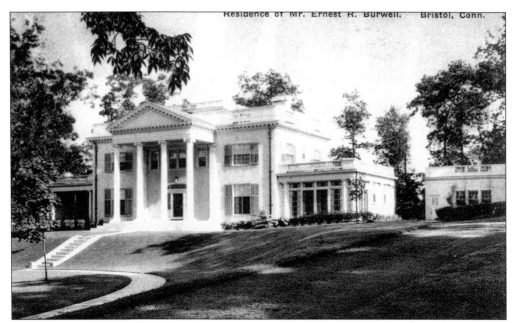

161 GROVE STREET. This house was designed by Walter P. Crabtree and was built in 1918 by the Central Building Company of Worchester, Massachusetts, for Ernest Romaine Burwell. Ernest Burwell, who was the son of John S. Burwell, began a retail coal and ice trucking business in 1893. He later formed Burwell and Barnes, a partnership with Clifford S. Barnes of Bristol. Burwell married Sally Gregory of North Orange, Massachusetts. He died in 1945.

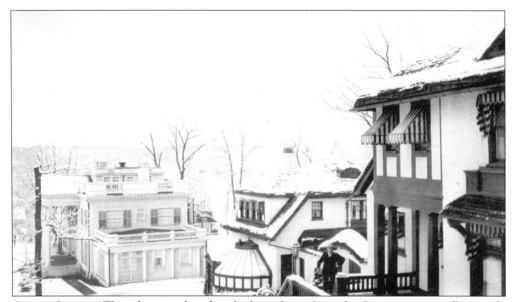

GROVE STREET. This photograph, taken looking down from the Page mansion, offers a side view of the Burwell home.

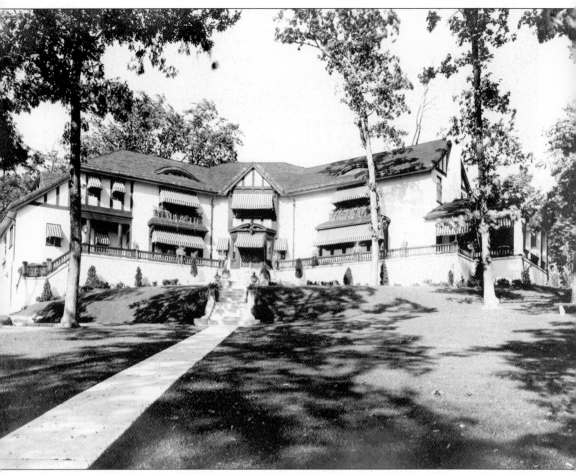

181 GROVE STREET. In 1917, Dewitt Page and Mae Page (née Rockwell) moved into this mansion from their home on 91 Bellevue Avenue. In 1933, the Pages donated 75 acres of land to the city for a park, now called Page Park. In 1936, Page established a trust fund of $100,000 for the maintenance and improvement of the park. After he died in 1940, his wife continued contributing, and in 1948, she gave the city the money to construct a swimming pool. She died in 1959, and in 1969, the mansion was given to the city. It was demolished on November 22, 1971, due to extensive vandalism. On November 12, 1981, the carriage house was demolished. All that remains of the mansion today are the stairs.

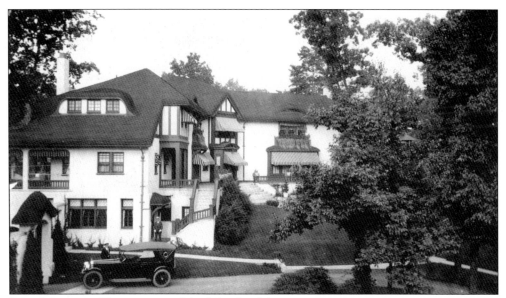

PAGE MANSION. This is a view of the left side of the mansion.

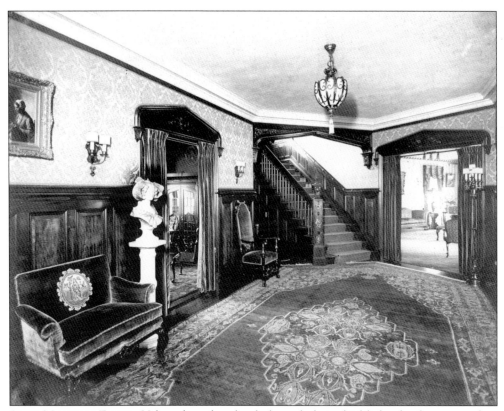

PAGE MANSION FOYER. Velvet-draped and upholstered chairs highlight the foyer, complete with oriental rugs and a curved stairway.

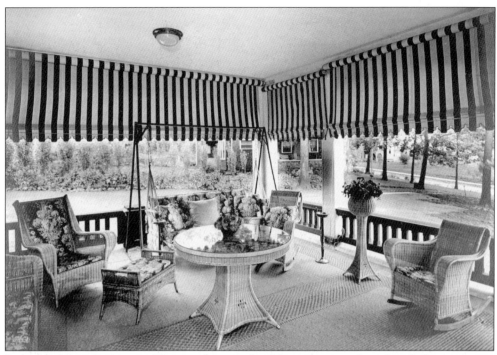

PAGE MANSION SUNROOM. This is a photograph of the sunroom with wicker furniture.

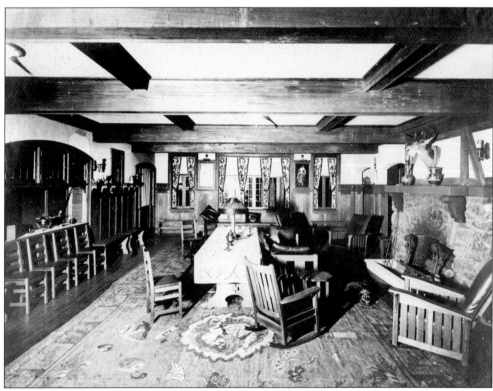

PAGE MANSION DEN. This antique den boasts rustic wood paneling and animal heads on the walls.

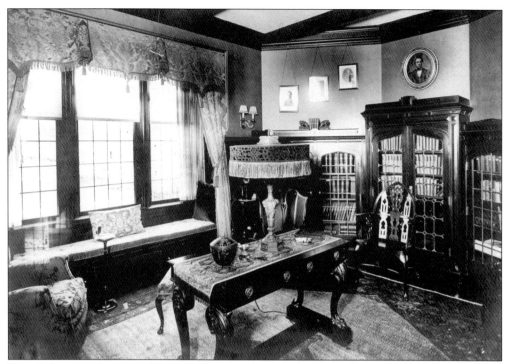

PAGE MANSION LIBRARY. This is a photograph of the library with wood cabinets. The drapes and lampshades have a Victorian look.

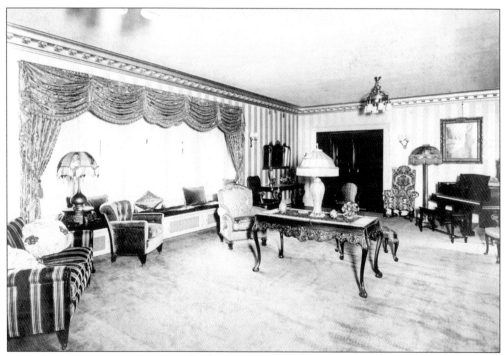

PAGE MANSION LIVING ROOM. The living room of the Page mansion was quite impressive, with a piano on the right.

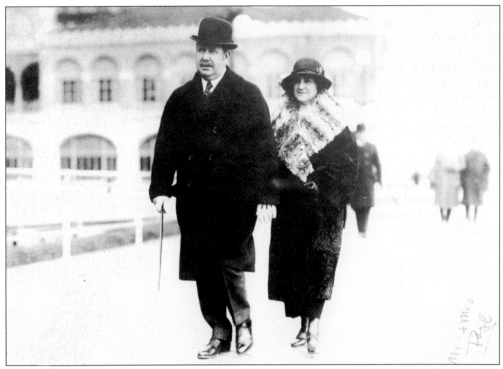

DEWITT AND MAE PAGE. This photograph, taken in the winter, features Dewitt and Mae Page.

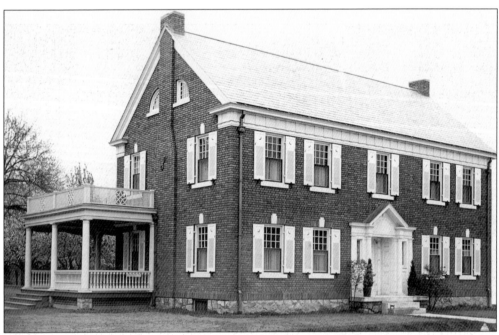

41 MERRIAM STREET. This was the first home of Fuller Forbes Barnes, secretary and treasurer of Wallace Barnes Company.

NEWELL JENNINGS. Born in Bristol in 1883, Newell Jennings was the son of John J. Jennings and Elizabeth Jennings (née Newell). He went to Yale Law School and joined his uncle Roger Samuel Newell in 1910 to form Newell and Jennings. In 1917, he became assistant state attorney, and in 1925, he became a judge in the Hartford Superior Court. He served on many boards in Bristol and was vice president and director of Bristol Savings Bank, secretary at Bristol Hospital, and a member of the building committee for the Bristol Girls Club. He died on February 17, 1965.

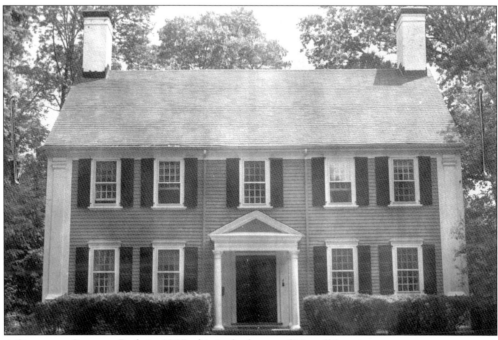

4 OAKLAND STREET. Built in 1917, this is the home of Newell Jennings.

FAITH INGRAHAM. Faith Ingraham, daughter of William S. Ingraham and Grace Ingraham (née Seymour), was born on April 30, 1886, in Bristol. Her brothers, Edward and Dudley, worked in their father's company, E. Ingraham Company. A member of the Bristol Quota Club, she was active in the community, with the Red Cross, and with the Bristol Visiting Nurse Association. On December 27, 1911, she married Morton C. Treadway Sr., an officer with the Horton Manufacturing Company. She died in 1983.

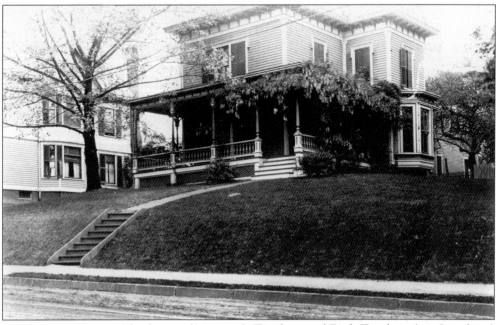

134 SUMMER STREET. This home of Morton C. Treadway and Faith Treadway (née Ingraham) was built around 1910. In this picture, wisteria is growing across the top of the porch.

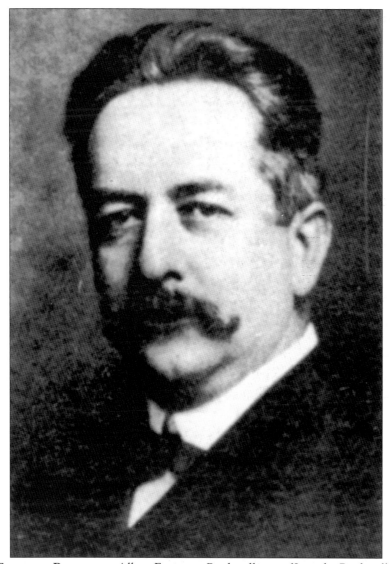

ALBERT FENIMORE ROCKWELL. Albert Fenimore Rockwell, son of Leander Rockwell and Fidelia Rockwell (née Locke), was born in 1862 in Woodhull, New York. He had three brothers, Frank, Edward, and George, and one sister, Mae, who married Dewitt Page. Rockwell arrived in Bristol with his brother Edward and leased space from the H. C. Thompson Clock Company on Federal Street to start their new doorbell company. In 1889, the company became New Departure Bell Company. Rockwell was married first to Nettie Rockwell (née Beebe) and had three children, Leander, Hugh, and Bernice. He then married Nettie Williams Brown. He introduced the bicycle lamp, and in 1887, he patented the famed bicycle coaster brake with Harry P. Townsend. Before Rockwell left New Departure, he joined the Bristol Brass Corporation. He pushed for the building of the workers' housing, which is now First through Sixth Streets. He purchased the Marlin Firearms Company of New Haven, formed the Marlin-Rockwell Company, and began producing machine guns. He also served as president and general manager of the American Silver Company. He donated 12 acres of land, then known as Dunbar Meadows, to the city to build a new high school. Today it is the Memorial Boulevard Middle School, and the road is named the Memorial Boulevard. Rockwell died in 1925.

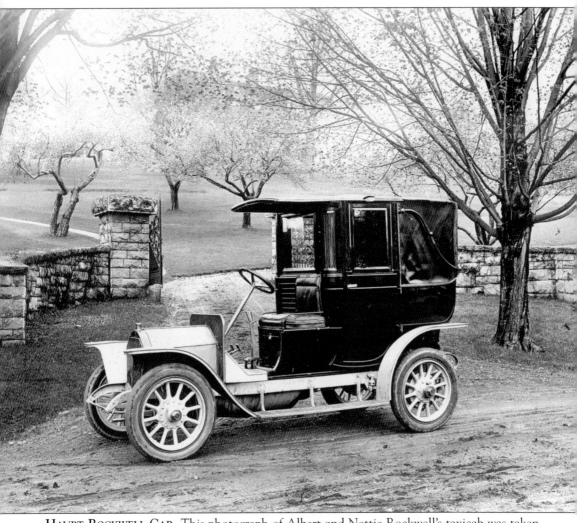

HAUPT-ROCKWELL CAR. This photograph of Albert and Nettie Rockwell's taxicab was taken in 1904 in front of the entrance to their Brightwood mansion. Albert Rockwell formed a separate company from New Departure that was called the Bristol Engineering Company. He manufactured these taxicabs, and between 1908 and 1911, he sent 500 to New York City and 200 to Chicago. His wife suggested that they be painted yellow for better visibility, hence the yellow cabs still used today.

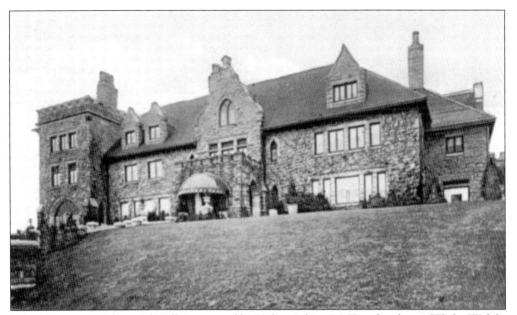

WEST STREET. Brightwood Hall was started by Helen Atkins-McKay, daughter of Elisha Welch, the clock maker. After purchasing the Tracy Peck estate in 1886, she planned this castle to be a monument to the Welch family. The granite stone came from the property, and in 1910, after spending $150,000, she died before the interior was finished. On October 31, 1911, Albert and Nettie Rockwell purchased the property for $30,000.

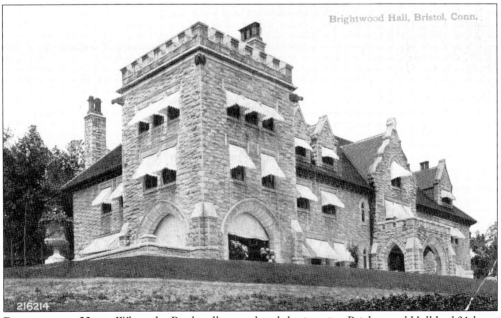

BRIGHTWOOD HALL. When the Rockwells completed the interior, Brightwood Hall had 21 large rooms, 5 corridors, 6 baths, 5 lavatories, and a foyer.

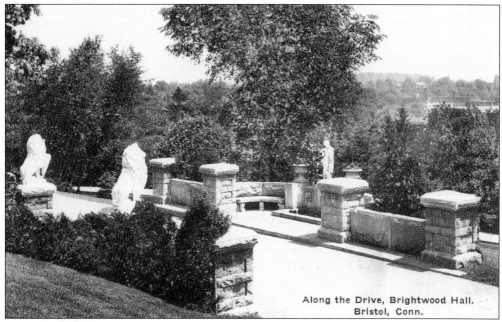

Along the Drive, Brightwood Hall.
Bristol, Conn.

BRIGHTWOOD HALL. There were white granite stairs that led from the driveway to the large entrance. The lions on either side of the main entrance were imported from Florence, Italy.

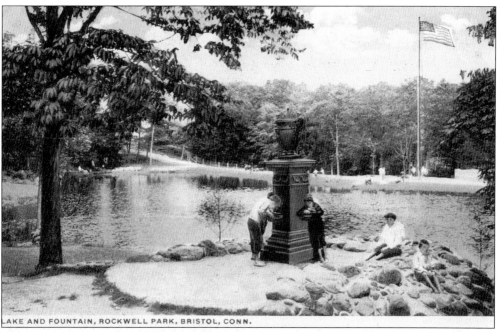

LAKE AND FOUNTAIN, ROCKWELL PARK, BRISTOL, CONN.

ROCKWELL PARK. In 1911, Albert Rockwell donated 80 acres of land adjoining his property for a park, on the condition that the city would spend $15,000 a year for upkeep for eight years. In 1920, he donated an additional 15 acres for a playground in the park. Rockwell died in 1925, and the mansion was put up for sale in 1928. In 1936, the mansion was sold to the Roman Catholic Church Society for $4,000 for the stone, marble, and bronze. The stone was used to build St. Ann's Church in New Britain.

Six

POST–WORLD WAR I
1920–1940

FULLER FORBES BARNES. Fuller Forbes
Barnes was born in 1887 to Carlyle Fuller
and Lena Forbes Barnes, who also had
another younger son, Harry Barnes. After
completing his education at local schools,
Fuller Barnes attended Phillips Andover
Academy and Yale, graduating in 1910.
He was in the ninth generation of the
original Barns family. He joined Wallace
Barnes Company in 1923, and the
company was reorganized as Associated
Spring Corporation. He became president
of the company. He was also the president
of the Bristol Hospital, which started as a
house purchased on the corner of George
and South Streets. In 1925, a new hospital
was built at its present site. Barnes married
Myrtle Ives, and together they had four
children, Edward, Louise, Carlyle, and
Aurelia. He died in 1955.

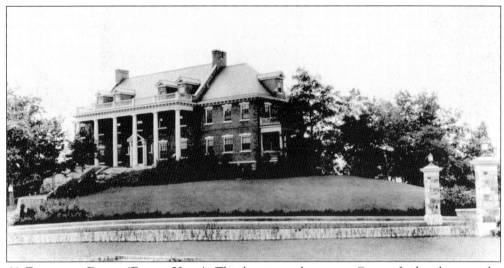

60 FOUNDERS DRIVE (FRONT VIEW). This home was known as Copper Ledges because the area was rich in copper. It was built for Fuller Barnes and his wife, Myrtle, in a 14-acre tract of land at the end of Stearn Street. The Barnes family moved in 1925, and in 1926, they added a swimming pool. Prior to his death, Barnes donated Copper Ledges to Bristol Hospital to be used as a convalescent home, which never happened. The mansion, like Chimney Crest, was part of Laurel Crest Academy and is a private residence today.

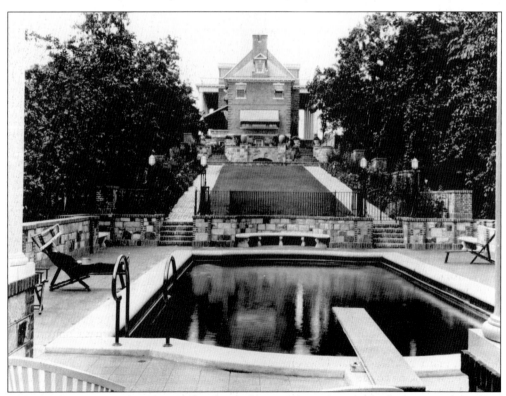

60 FOUNDERS DRIVE (REAR VIEW). This is the view from the pool looking up to the side of the house. Notice Fuller Barnes relaxing on the chair by the pool.

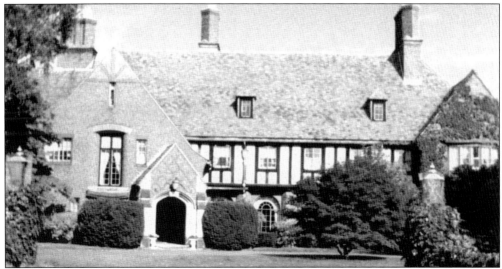

5 FOUNDERS DRIVE (FRONT VIEW). Known as Chimney Crest, this was the home of Harry and Lillian Barnes. It was designed by Perry and Bishop of New Britain and was completed in 1931. There are 32 rooms, with a ballroom in the basement, six fireplaces, a library, a sunroom, a formal dining room, and a living room. In 1955, the property was sold to a developer and became the Laurel Crest Academy for eight years. Today the mansion is the Chimney Crest Manor Bed and Breakfast.

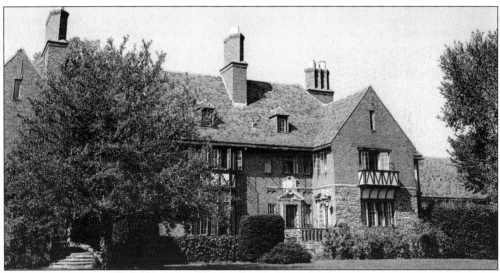

5 FOUNDERS DRIVE (REAR VIEW). Harry Clark Barnes was born in 1889 to Carlyle Fuller and Lena Forbes Barnes of Bristol. He was a descendant of Ebenezer Barns, who in 1728 became the first settler of Bristol. Harry Barnes attended local school, followed by Holbrook Military Academy and the New England Conservatory of Music. At the age of 24, he joined the family business. He and his brother, Fuller Forbes Barnes, developed Wallace Barnes Company into Associated Spring Corporation. They had multiple plants in the United States and Canada. In 1914, Harry married Lillian Houbertz, who came from Fultonville, New York, to develop and teach a cooking course in public schools. Together they had four children, Wallace, Harry Fuller, Edith Forbes, and Nancy Lee. The family moved from this home to Green Acres Farms on Perkins Street.

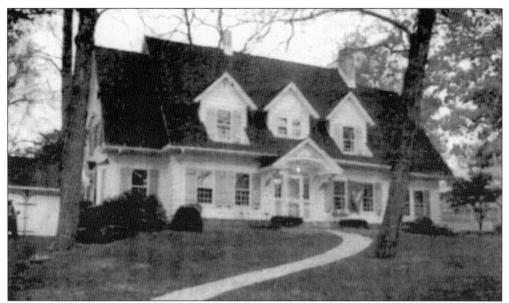

29 CARLSON PLACE. Originally, Dr. Arthur S. Brackett, a Bristol physician, owned the land this house was built on. Brackett sold the land to Frederick Hughes in 1920. In 1926, S. Russell Mink and his wife, Edith, built this home. Mink was an attorney, judge of probate, and city court judge in Bristol.

24 FOUNDERS DRIVE. In 1960, this home was known as Sterns Hall and was part of Laurel Crest Academy, a private boys' high school. The school started in 1960. When a girls' school was added in 1970, the name changed to Devonshire-Laurel Crest. The school closed a year later, in 1971.

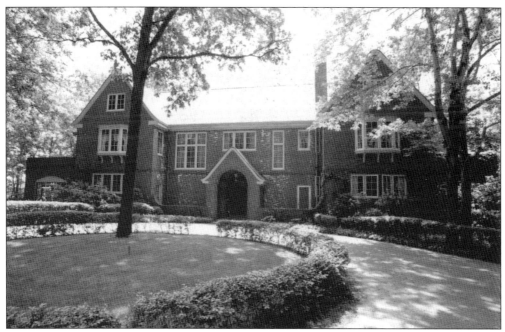

BROADVIEW AND OAKLAND. Morton C. Treadway and Faith Treadway (née Ingraham) built this home, called Hickory Hill, in 1924. Prior to this, they lived at 134 Summer Street. Richard H. Dana Jr. was the architect who designed the home, and it was built by the Torrington Building Company.

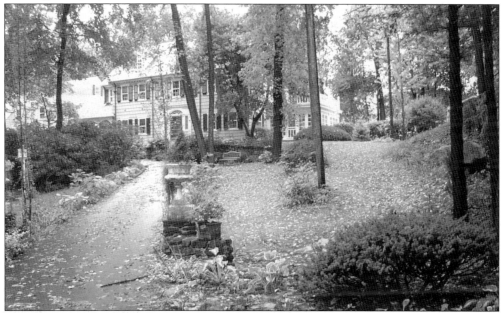

80 BROADVIEW STREET AND WOODLAND STREET. Known as Knollwood, this home was designed by Goodell and Root and was built by Peck and Barnard in 1923 for Howard Seymour Peck and his wife, Edna R. Peck. Peck was a descendant of the founders of Bristol Savings Bank, started by Josiah T. Peck and Henry A. Seymour. He was a clerk at Bristol Savings Bank and also worked with M. L. Peck and Sons, an insurance company.

EDWARD INGRAHAM. Born in Bristol in 1887, Edward Ingraham was the son of William S. Ingraham and Grace Ingraham (née Seymour). He attended Phillips Andover Academy and graduated from Yale in 1910. After graduation he began working at E. Ingraham, first as a paymaster and then as a billing clerk. He married Alice Patti Pease in 1918, and they had four daughters and one son. In 1927, Ingraham married Ethel Leishman, and that same year he founded Bristol Clock Museum, which was renamed the American Clock and Watch Museum in 1958. He died in 1972.

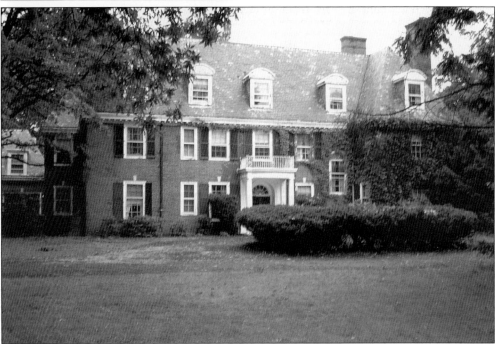

226 GROVE STREET. Edward Ingraham named this house the Marlborough House, after his great-grandfather Elias Ingraham, who was born in Marlborough. Designed by Richard H. Dana Jr., the house was built in 1929 by Torrington Building Company.

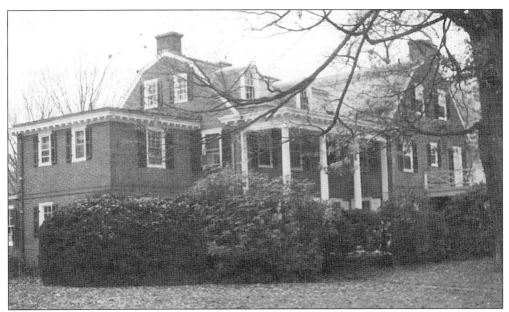

100 OAKLAND STREET. Townsend G. Treadway, son of Charles Treadway, was a descendant of Eli Terry. He served on the board of directors of the Bristol Brass Corporation, the Bristol Bank and Trust Company, and the Bristol Hospital. He was also a secretary for the Horton Manufacturing Company. This house was designed by Murphy and Dana and was built by the Edward F. Miner Company of Worchester, Massachusetts. The original house was built in 1915, and an addition was built in 1936. Treadway died in 1972.

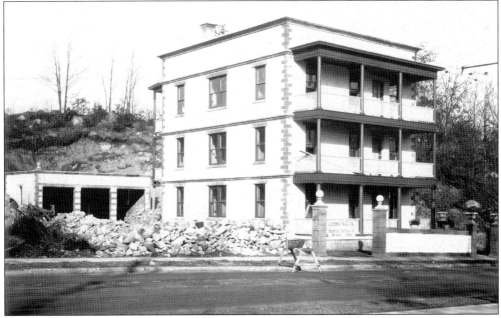

438 PARK STREET. Cosmo Vacca, born in Lanusei Caglari, Italy, in 1882, came to Bristol in 1907. He established the South Sand Gravel Company on Terryville Road. Vacca built this apartment building around 1920. He also built St. Joseph's Church and other buildings. He died in 1938.

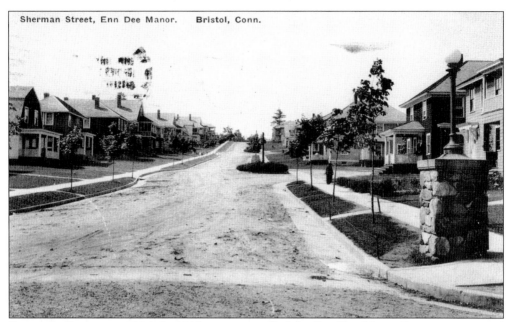

Sherman Street, Enn Dee Manor. Bristol, Conn.

SHERMAN STREET IN 1924. In 1916, a project called the Enn Dee Manor Project was created with the goal to build 101 homes in 101 days. These homes were to be sold to employees of New Departure at nearly cost, with only a 10 percent down payment. Later, Bristol Realty Company was organized to provide more housing.

80 BELEDEN GARDENS DRIVE. Once the gardens from the Beleden Mansion were sold for development, all the homes on this street were built for William Edwin Sessions's family members and top employees. This home was built in 1936 and belonged to William Kenneth Sessions Jr. and his wife, Phebe. William was the grandson of William Edwin Sessions, who owned Sessions Clock Company and Session Foundry.